MINCHINHAMPTON & AMBERLEY
THROUGH TIME

Howard Beard

AMBERLEY PUBLISHING

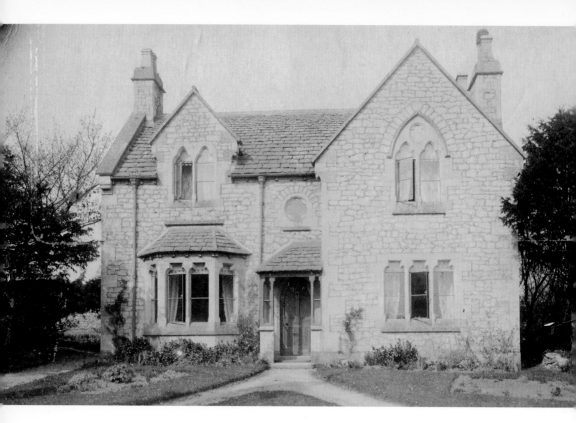

School House Minchinhampton circa 1920

First published 2009

Amberley Publishing Plc
Cirencester Road, Chalford,
Stroud, Gloucestershire, GL6 8PE

www.amberley-books.com

Copyright © Howard Beard, 2009

The right of Howard Beard to be identified as the
Author of this work has been asserted in accordance
with the Copyrights, Designs and Patents Act 1988.

ISBN 978 1 84868 047 0

British Library Cataloguing in Publication Data.
A catalogue record for this book is available from
the British Library.

Typeset in 9.5pt on 12pt Celeste.
Typesetting by Amberley Publishing.
Printed in the UK.

Introduction

The invitation to research and compile this photographic study was a welcome one. Minchinhampton and Amberley are areas of considerable natural beauty, with great open spaces and fine distant views. The Common draws people, both from the locality and further afield, to enjoy golf, walking, exercising dogs, picnicking, kite-flying, searching for wild flowers, or simply watching sunsets.

Also, the architecture of the area is most attractive. Local buildings — many listed — are constructed from the greyish-white limestone native to the district, much of it extracted from quarries such as the great mines at Box.

In addition there are more personal reasons why the author is fond of this corner of the Cotswolds. Through families such as the Kings, Cowleys, Duttons and Hills, his ancestral lines can be traced back to the start of the earliest parish registers of Minchinhampton in the 1560s. There are also more recent connections: the author's children attended Amberley Parochial School and his wife was on the staff there in the 1970s. He himself taught at Minchinhampton from 1976-1987.

Historically, before the nineteenth century, Minchinhampton Parish included Amberley, Brimscombe and parts of Nailsworth such as Watledge.

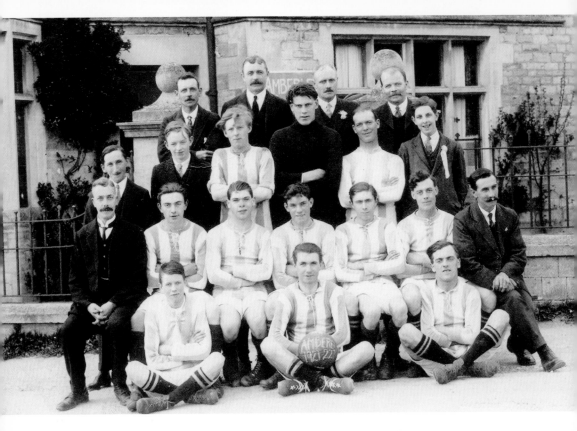

Amberley football team, 1921-22, photographed outside The Amberley Inn

However, for reasons of space, only Minchinhampton, Box and Amberley are included in this book. Parish boundaries have, with the odd exception, been adhered to. If readers find that certain hamlets are unrepresented, such as Hampton Fields or Hampton Green, this is either because promising photographs were not available to the author, or images had already been used in previous books. In fact, the vast majority of early pictures chosen here have never before appeared in print. A few views of school and church groups have been inserted; they will serve to stir memories for local people.

However, alongside the enjoyment derived from involvement in this project, a couple of problems arose. For example, photographs of Minchinhampton town centre, it may be argued, need people to bring them to life.

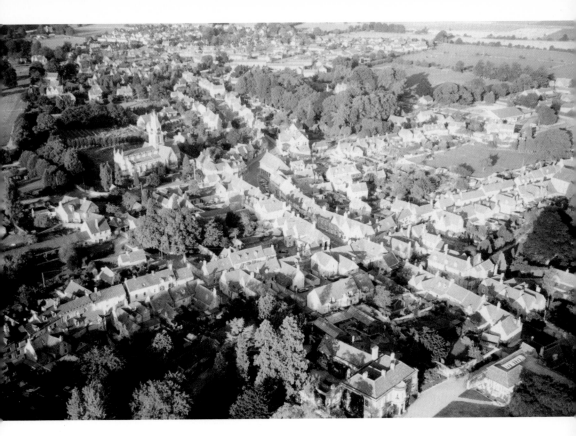

An aerial view of Minchinhampton taken by the author from a hot air balloon in June 1993

In practice the daily profusion of cars and delivery vans provide an unavoidable and unwelcome distraction. Trees also proved problematical. Three or four finely composed late-nineteenth-century pictures had to be discarded because modern tree growth prevented any matching image from being taken.

In conclusion, the research, photographic work and compilation of this book has allowed the author the pleasure of making fresh contacts and also renewing many old acquaintanceships. It is to be hoped that readers will derive equal enjoyment from observing how this attractive area has altered through time.

Howard Beard. 2009

MINCHINHAMPTON

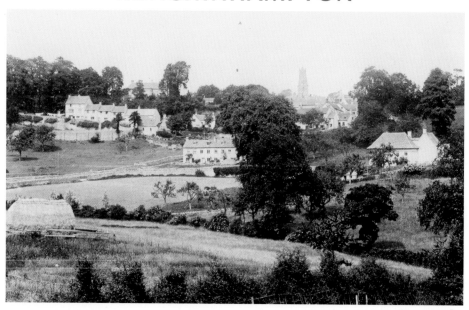

The Town from the South

From a scenic point of view, Minchinhampton is perhaps best approached from the south, via Forwood. Note the well-thatched rick on the left in the Edwardian picture. Excluding tree growth, relatively little has changed over a century or so. The distinctive church steeple stands as a landmark in both photographs.

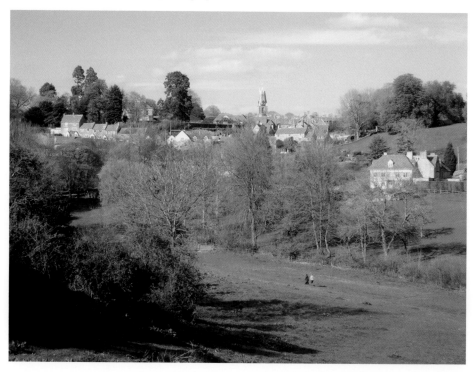

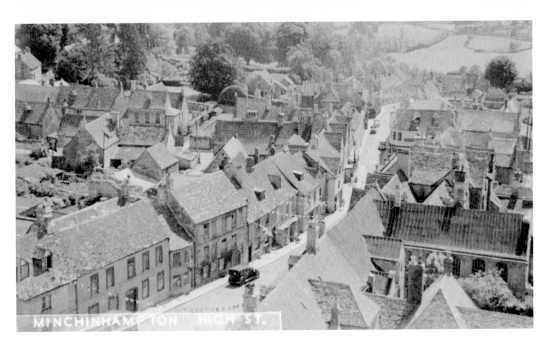

Minchinhampton from the Church Tower

The flags across the street suggest the earlier picture may have been taken at the time of George V's Silver Jubilee in 1935. Traffic apart, the centre of the town remains substantially unaltered, although a closer inspection reveals the addition, over time, of the odd building – for example on the far left of the picture. The ascent of the church tower, to take the present-day photograph, was made possible by the kindness of the Steeple Keeper, Mr Shellard.

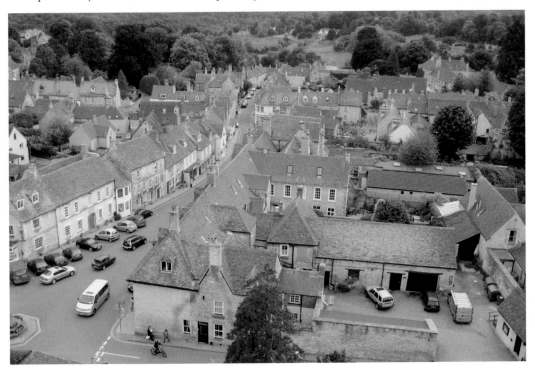

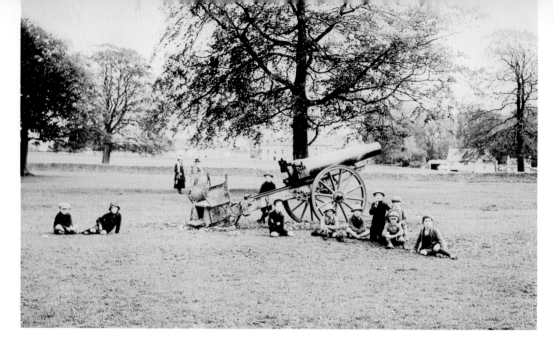

The Park

The postcard showing the cannon in The Park was posted on New Year's Day 1922. When the gun was placed there is not clear. It seems to have disappeared during the last war, probably as part of the Government drive to acquire metal for armaments. In 1902 Post Office regulations first allowed the whole of one side of a postcard to be given over to a picture. This resulted in postcard collecting becoming a very popular pastime. Photographers working during this early period tried to include as many youngsters in the frame as possible: their parents and relations were, of course, potential customers for the resulting postcard.

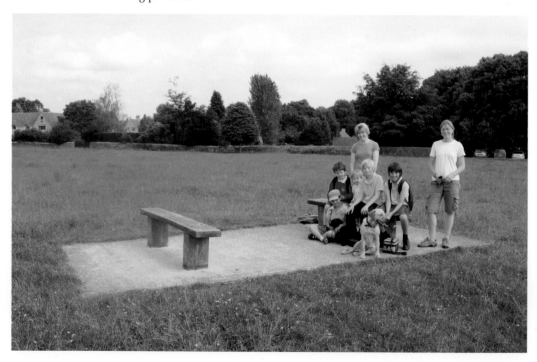

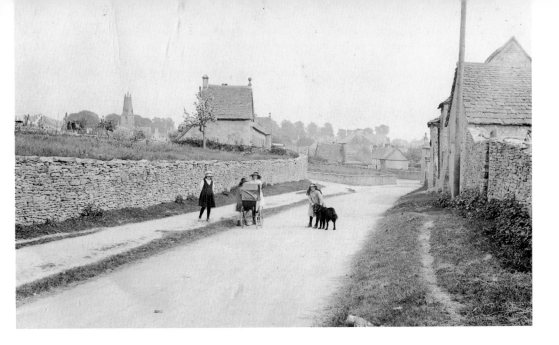

Windmill Road

Housing development around Windmill Road has mostly happened since the earlier picture was taken. The girls had no doubt been told to take the dog for a walk and give the baby some fresh air. The child on the right appears to be restraining her pet from approaching too close to the photographer. Note the rough verges and the un-metalled state of both carriageway and pavement. The windmill, after which the road was named, stood at its western end and was demolished in the 1870s.

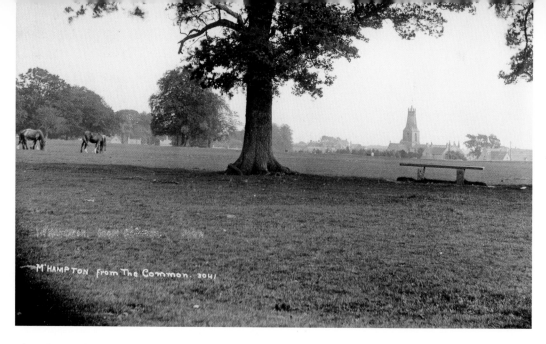

The Church from the Park

Many of the finest pre-1920 photographs of Minchinhampton were taken – like this one – by the Nailsworth photographer E. P. Conway. His output amounted to more than 6,000 images, although not all were topographical. Owing to the disappearance of old trees from The Park and their replacement by new ones, it is not possible to be sure exactly where Conway stood to take this view, but his serial number, 3041, suggests it dates from *c.* 1913.

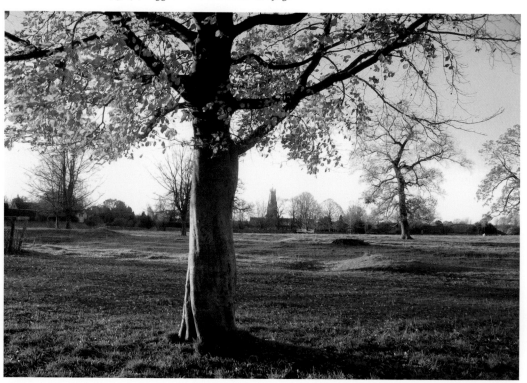

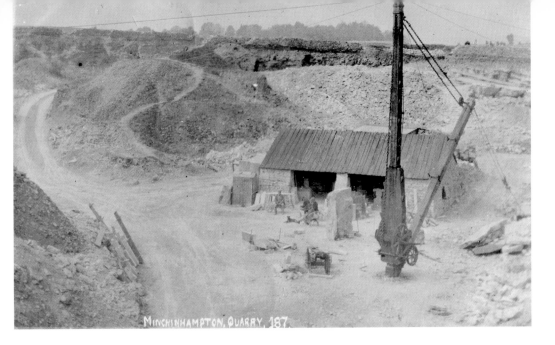

MINCHINHAMPTON, QUARRY, 187

Crane Quarry

Stone has been extracted in Minchinhampton for centuries. Extensive mining of it took place at Balls Green, with tunnels extending considerable distances into the hillside. Evidence of surface quarrying may be found in many places on the Common. Sometimes these appear as shallow depressions (what as children we referred to as 'dippies') from which walling and road stone were taken or, as here at Crane Quarry, situated near Tom Long's Post just off the road from The Bear Inn, more substantial workings where weather stone and Hampton stone were excavated. The picture, from around 1910, shows how the quarry acquired its name. The modern photograph was taken during the severe weather of February 2009.

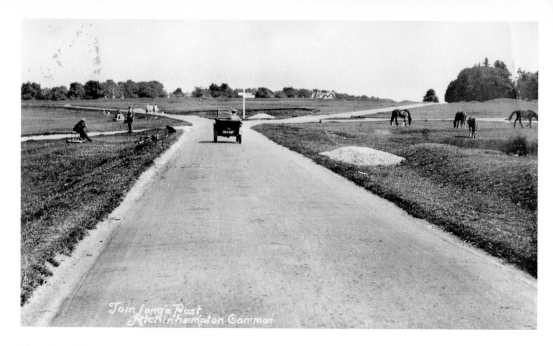

Tom Long's Post

Tom Long's Post, which, according to the *Victoria County History of Gloucestershire*, reputedly takes its name from the place of burial of a suicide, marks the meeting point of the five roads that lead to Rodborough, Brimscombe, Cirencester, Amberley and Minchinhampton town itself. Since visibility for traffic is obviously good, the crossroads has, surprisingly, been the scene of many accidents over the years. At one point, in an attempt to reduce these, the roads out from the town and from Amberley were realigned, making, in effect, two junctions. The author chose his moment carefully when taking the modern picture.

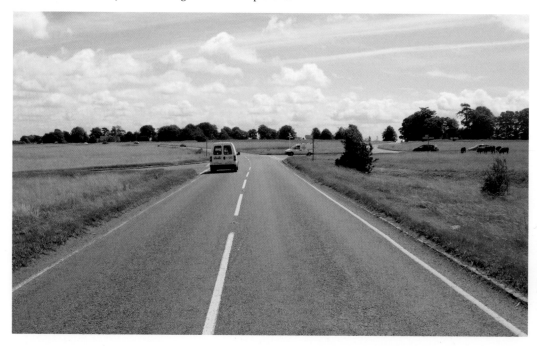

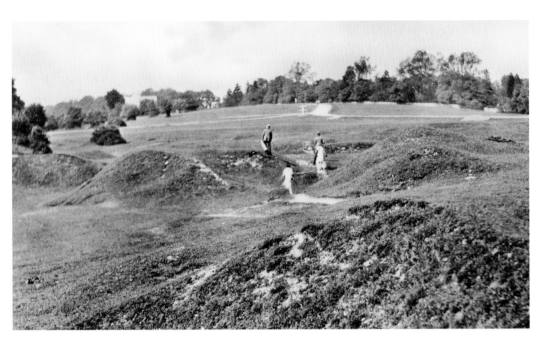

The Fifth becomes the Eighth

As a non-participant, the author needed to ask a group of golfers the number of the green shown here. Back in the 1920s or 1930s, when the sepia picture was taken, it was clearly the fifth. Now it would appear to be number eight. The earlier photograph reveals something else of interest: the two golfers are male, but their caddies appear to be ladies.

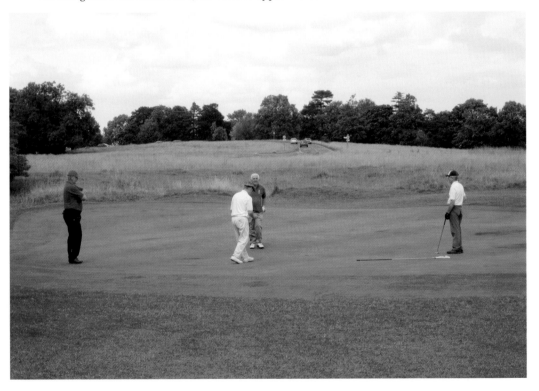

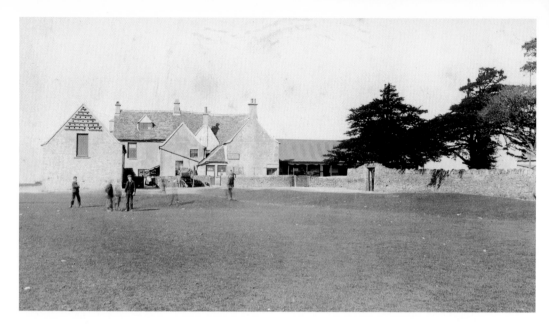

The Old Lodge

A. T. Playne's book, *Minchinhampton and Avening*, published in 1915, informs the reader that, 'this celebrated and beautiful expanse of downland was, until quite recent years, but little known and rarely visited by strangers' – certainly a contrast to today. The seventeenth-century Old Lodge, however, has entertained visitors for a very long time; Charles I is reputed to have dined there. By 1718 it boasted a bowling green. In 1889 the Minchinhampton Golf Club was founded, with The Lodge forming its headquarters in 1895. The Old Course Club House is currently located a few yards away and The Old Lodge itself continues to offer refreshment to drinkers and diners.

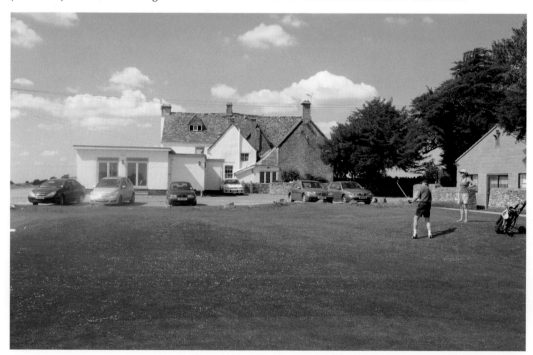

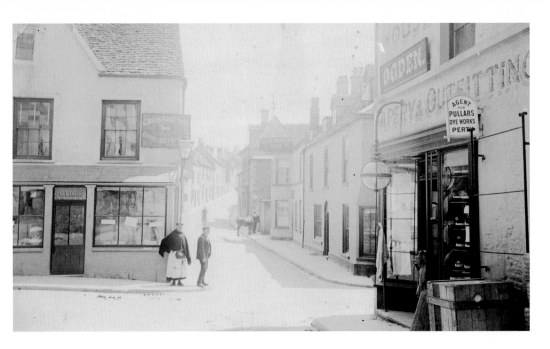

The Cross

In 1910, roughly when the earlier picture was taken, the gabled building on the left was described as a drug store and livery stables and was run by Charles Viner. On the right was Ogdens – later Murrays – a drapery business that only ceased trading in the last decade or so, but which had a continuous history back at least as far as 1856. Two present-day passers-by observe the photographer from the same spot as the lady in the shawl and apron did a century ago.

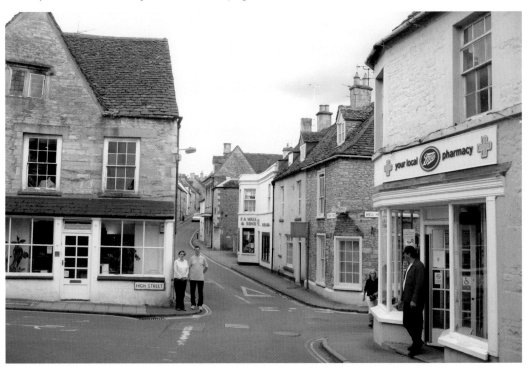

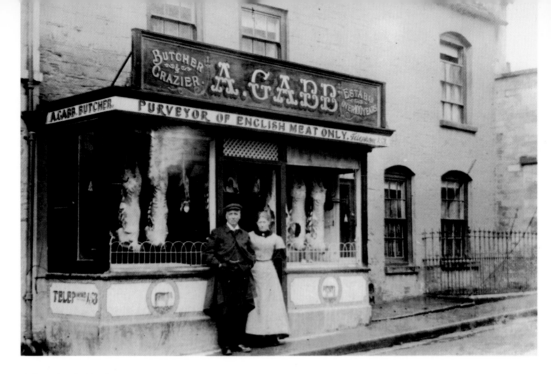

A Butcher's Business

The Edwardian couple posing in front of their West End shop are presumably Mr and Mrs Alfred Gabb. Their business was bought in 1920 by the Taylor family, whose descendants still run it today. Stephen and Mark Robinson – cousins of the author – appear in the modern picture. Could it be that it was on this site that their common ancestor, George Hill, sold meat in the town in the mid-sixteenth century?

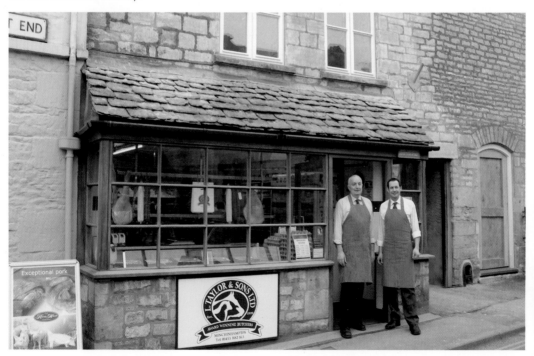

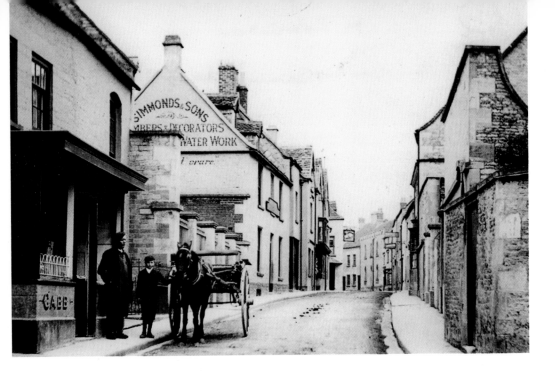

Looking Up West End

In the sepia picture a pony and trap – perhaps a delivery vehicle or maybe transport for a customer – wait outside Gabb's shop. In the background are the premises of the long-established firm of James Simmonds and Sons, described in Kelly's 1910 Gloucestershire Directory as plumbers and insurance agents. Alterations have taken place to buildings immediately behind the pony and trap. In the distance the inn sign for the former Swan public house is visible. A hundred years on, horse manure has been replaced by double yellow lines.

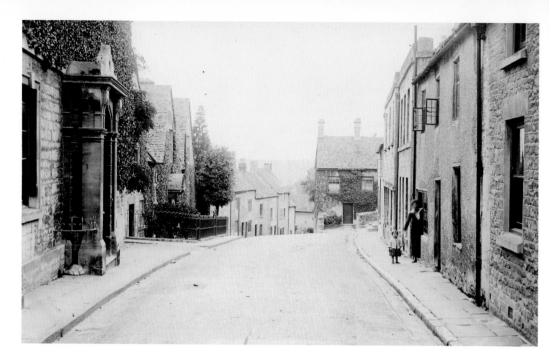

Looking Down Well Hill

A century has seen relatively little change to the external appearance of buildings in this street, which leads southwards out of the town. The odd chimney has disappeared and several houses have brightened up their frontages with hanging baskets. A mother and daughter stand where, a hundred years earlier, another parent stood with a much younger child. The house face-on in the middle distance, today home of centenarian Miss Gladys Beale, is covered with foliage in both pictures.

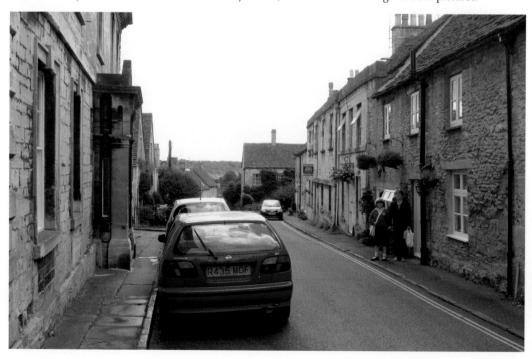

The Coffin House

Some would have it that this cottage was so named because it housed an undertaker's business. A more likely explanation is to be found in its curious shape. The earlier picture, a printed postcard sold from the Jones' shop in Well Hill, suggests that the entire population of King Street had turned out for the photographer. In the modern picture note the metal kissing gate.

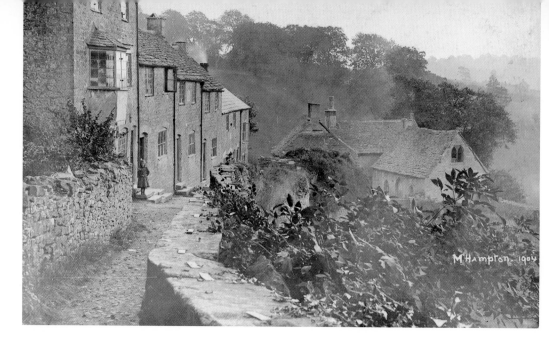

King Street

King Street contains a terrace of cottages enjoying pleasing views down the valley towards Longfords. The modern picture records the demolition of the bungalow that was the home of John and Doris Elliott. Mr Elliott will be remembered as a fine musician who, for many years, conducted the Stroud Light Music Choir. The top end of King Street becomes a narrow path that, passing through a tunnel beneath The Lammas garden, emerges into Cuckoo Row.

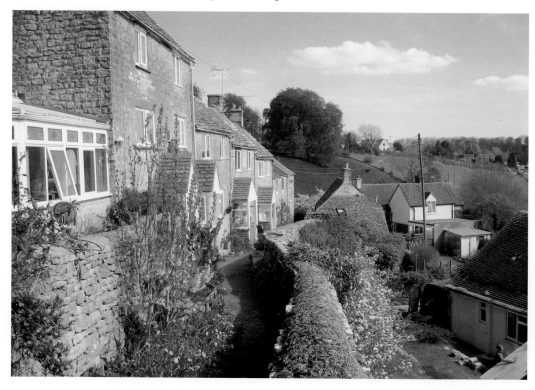

Parson's Court

So much has changed here. The demolition of almost everything visible in the older picture allowed the creation of the car park, approached from Friday Street. An exposed gable and a building on the horizon reassure the viewer that he is in fact standing in the same place as the photographer who took the earlier image.

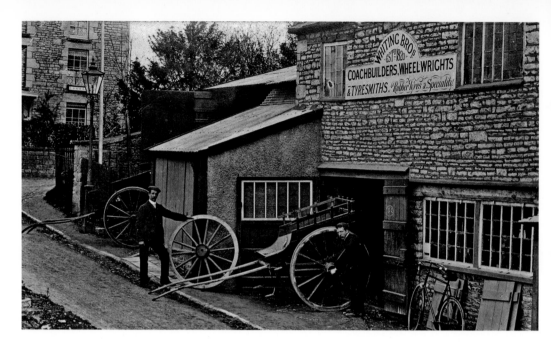

Whiting's

On the east side of Butt Street stood the former premises of Whiting Bros., coachbuilders, wheelwrights and tyre-smiths. The man on the left, with his hand on the cartwheel, is Harry Francis Smith. The present name of the property, Wheelwright, perpetuates the memory of the business it once housed. A porch replaces the former workshop extension.

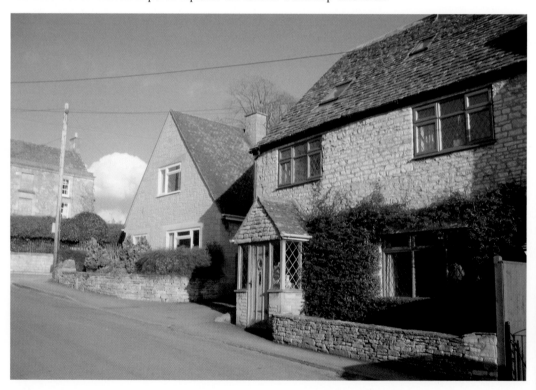

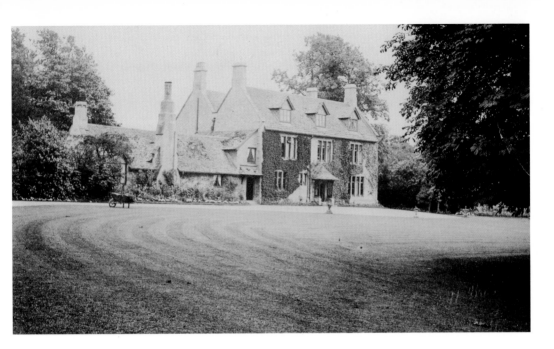

Stuart House

This property is named after the lady who lived in it from 1944 up to her death, when it was bequeathed to the Gloucestershire Association for the Disabled. It was built in the early eighteenth century by Samuel Sheppard, Lord of the Manor, as Minchinhampton's rectory – a residence for his second son, Revd Philip Sheppard. During the early nineteenth century it housed the curate, as the rector, Revd Cockin, had inherited The Lammas and preferred to live there. The house was altered in the 1860s and sold around the time of the First World War, when The Coigne, near the Market House, became the rectory.

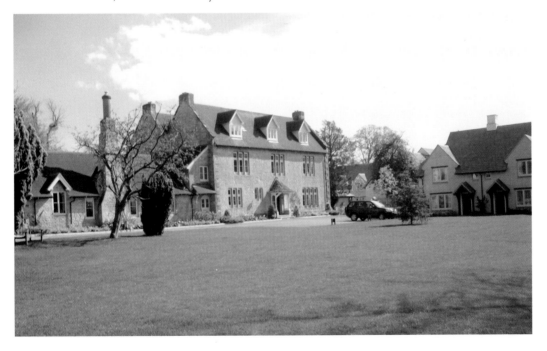

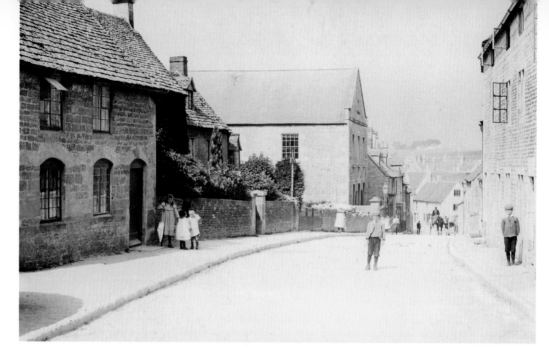

Looking Down Tetbury Street

The period photograph, again by E. P. Conway of Nailsworth, must predate 1907, since the Baptist Institute, on the left of the chapel in the modern picture, does not appear on it. A few other superficial changes are detectable – a garage on the left, a window on the right. Notice also in the earlier image a 'summer gas-lamp' in front of the chapel window – that is to say, one with its head removed and put into store until the arrival of darker evenings.

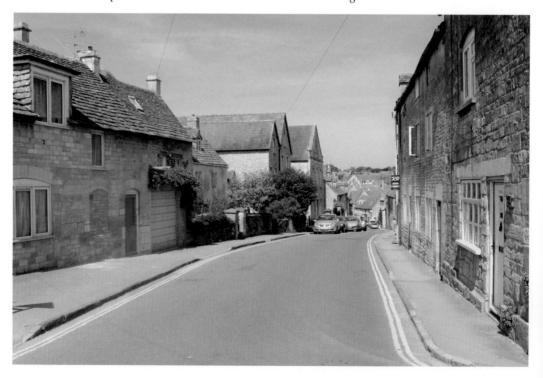

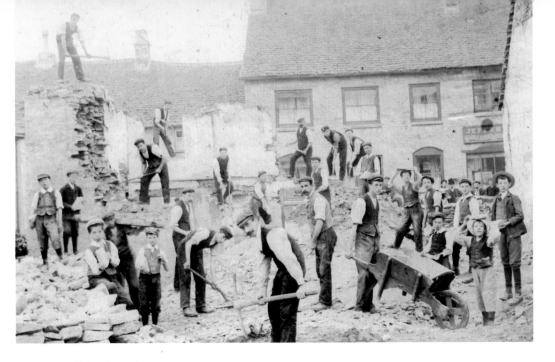

Demolition in Tetbury Street

Around 1907 plans were put forward to build an Institute to serve the needs of the Baptist community and, indeed, of the whole town. This involved the demolition of the cottages seen next to the chapel in the previous photograph. The clearing of rubble was undertaken by members of the congregation, as the upper picture shows. (An accompanying photograph in the Minchinhampton Local History Group's Archive shows the minister, Revd S. Ford, up aloft, assisting with the clearance.) The cottages on the north side of Tetbury Street appear in both pictures.

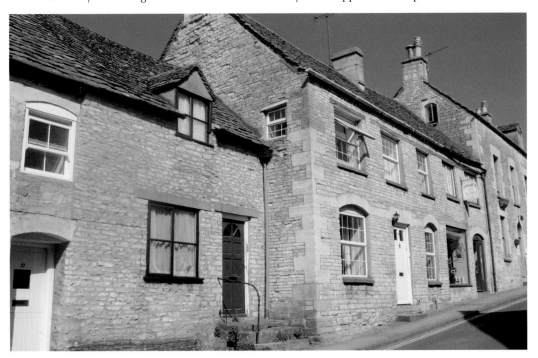

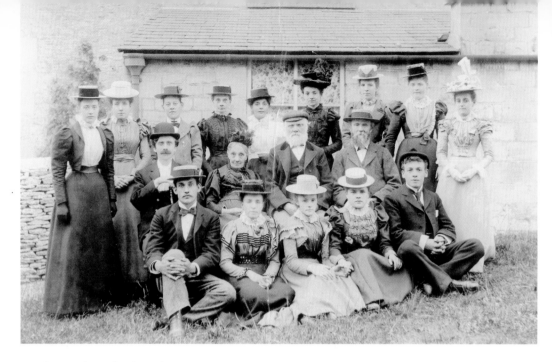

Baptist Sunday School Teachers

A chapel for Baptist worshippers was put up in 1765, instigated by Revd Benjamin Francis of Shortwood, near Nailsworth. It is now a private house. In 1834 the present structure in Tetbury Street was erected. The Edwardian photograph reproduced here is one of the best in the collection of the Minchinhampton Local History Group. The Baptist Sunday School teachers have clearly all put on their very finest attire and are pictured in the small graveyard behind the chapel. Nowadays 'Sunday Funday' is the equivalent event to Sunday School and is held at the youth centre. The inset picture shows the team who run it.

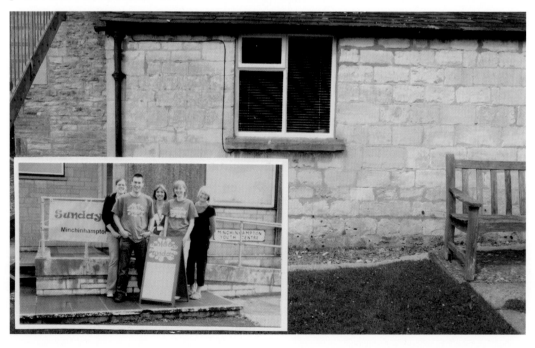

From Tankards to Televisions

The strictly teetotal Baptists seen in the previous picture would certainly never have ventured across the threshold of The Salutation Inn at the bottom of Tetbury Street. (Even as late as the 1950s the author, then attending the Baptist Chapel in Stroud, was mentioned with great disapproval at a church meeting for having purchased a bottle of cider at Cashes Green when on a church ramble!) According to detailed research by Diana Wall and Susan Francis, The Salutation Inn is traceable back at least to 1695. It remained a licensed public house until the 1960s, when it was sold to Frank Wall, who ran from it the electrical business, which still operates there today. The modern picture shows, from left to right, Clive, Diana and Eric Wall.

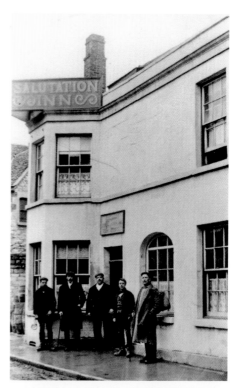

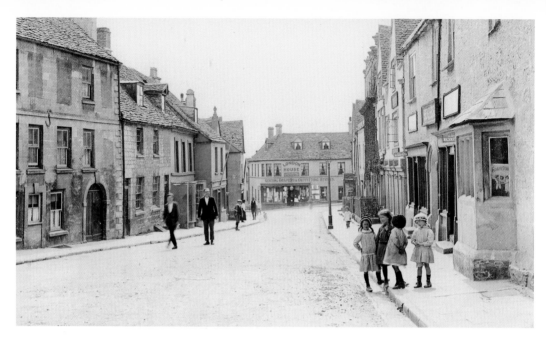

The High Street, Looking Down

As the present day photograph shows, the High Street is usually crowded with motor vehicles. What a delightful contrast the Edwardian picture provides: men strolling unconcerned, children chatting at the kerbside and, on the right, several shop windows with their decorative signs – long since gone. On the left, further down the street, George Casseldine's barber's pole is just visible. Another example of a 'summer gas lamp' can also be seen.

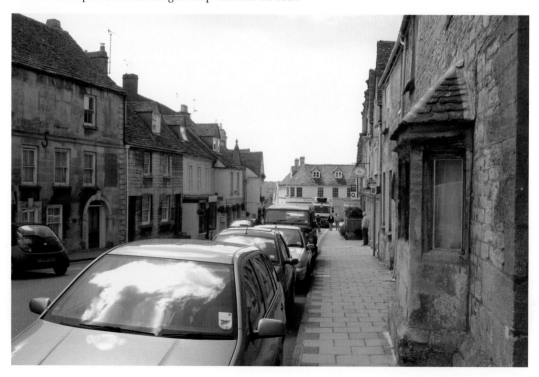

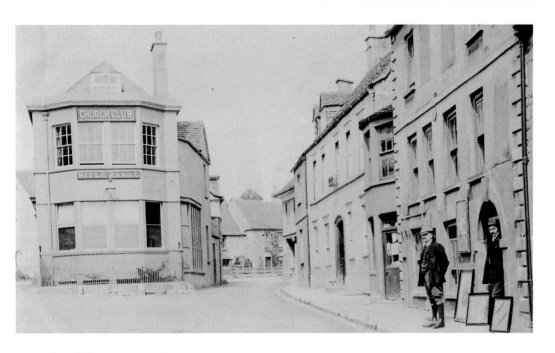

The High Street, Looking Up

What makes the sepia picture look so unfamiliar is the building known as Lower Island (Upper Island, which once stood in the triangle of open tarmac beyond the Market House, was demolished in 1858 and is, therefore, photographically unrecorded). As the sign makes clear, Lower Island contained a church club and rifle range – the latter housed safely in the cellar. School cookery lessons were also held in the building, which was pulled down around 1920.

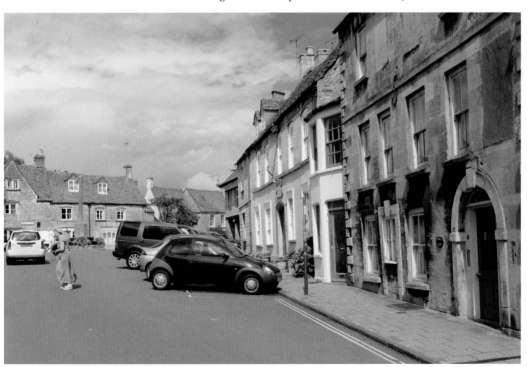

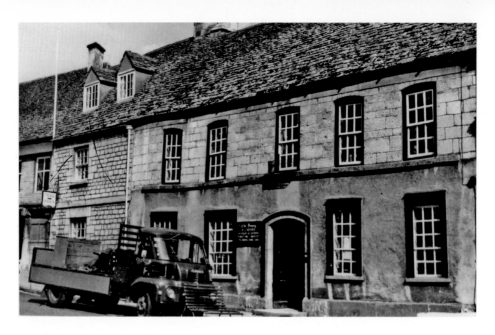

A Real Minchinhampton Character

For most of the second half of the last century John Vosper – Johnny to his friends – ran a successful second-hand furniture and antiques business from The Priory in the High Street. In the top picture his lorry can be seen, with his purchases just off-loaded from some local auction. Johnny's niche in the market was to pick up anything for which no one else at a sale would bid. This often resulted in bargains for his many faithful customers. At successive Minchinhampton Fayres Johnny would dress as a jester. He is seen here at the 1977 Silver Jubilee celebrations with the author's daughter, Sally, and Sarah Smith. At his funeral in 2008 the jester's staff of office, seen here in his right hand, was – appropriately – placed on his coffin.

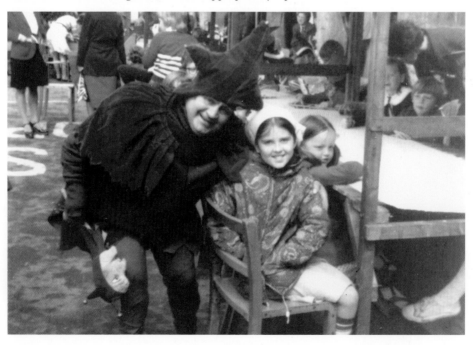

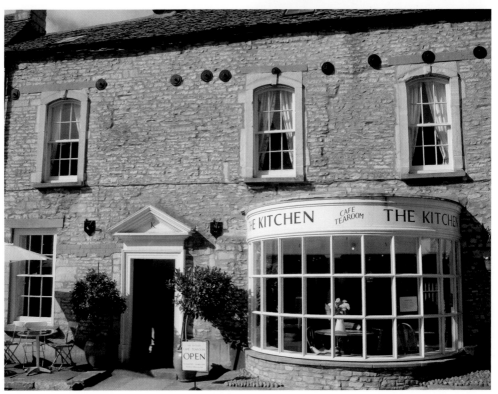

From Bikes to Buns

For many years Harry Walker ran his cycle business (telephone number Brimscombe 73) from premises in the High Street. An intriguing sign in his window reads, 'Your pram retyred with North Pole pram tyring while you wait'. Another notice says, 'Cars for hire', and one wonders whether the splendid machine parked at the kerb is his. More recently, having acquired a large bow window and pedimented doorframe, the shop became a restaurant – first The Coffee Bean and latterly The Kitchen.

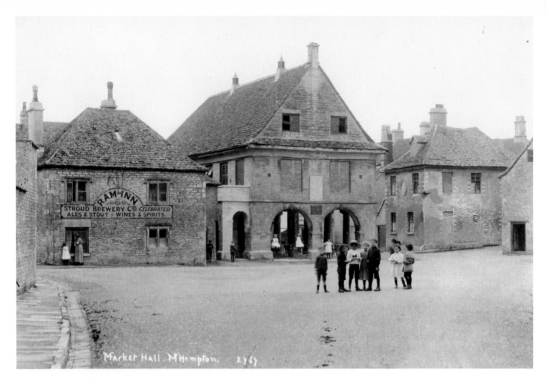

Market Hall. M'Hampton. 2767

The Site of Upper Island

In the earlier photograph the rear of Lower Island can be seen and also The Ram Inn, one of Minchinhampton's many licensed houses. The author's thanks go to Rod Harris, retiring head teacher of Minchinhampton Parochial School, and to his pupils who re-created (hopefully during a prolonged lull in traffic) the positions of their counterparts just one hundred years ago.

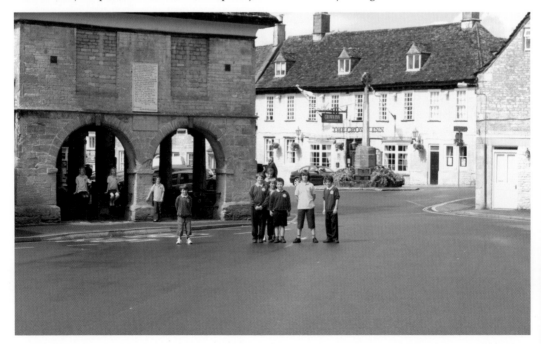

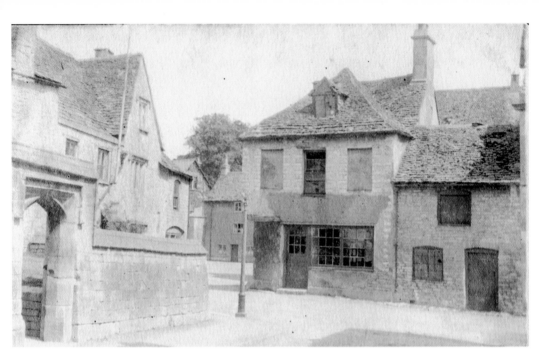

Bell Lane

On the left of this picture time seems to have stood still: the church entrance gate, the cottages beyond, even the plants peeping over the churchyard wall appear the same. But the right side of the image shows a different story: the gas lamp has gone and the demolition of Lower Island now allows the Market House to be seen. Using the sepia photograph, and two previous ones, it is possible to reconstruct what Lower Island looked like from almost all angles.

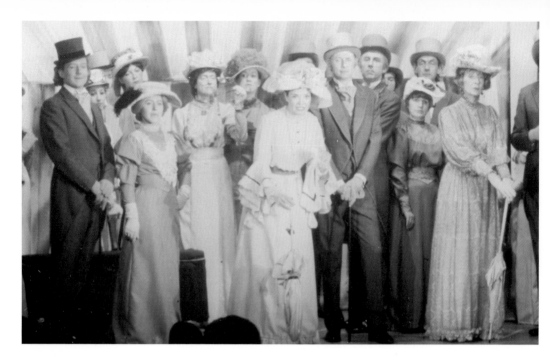

My Fair Ladies

2009 has seen the final demise of the long-established Minchinhampton Dramatic Society. It therefore seems fitting to record its passing with images from two productions of the musical 'My Fair Lady'. The earlier image of 1977 shows the author's wife, Sylvia, as Eliza Doolittle at Ascot, about to urge on a racehorse with those immortal words, 'Come on, Dover... '! In the 2006 production a later Eliza, Claire Fairbairn, concentrates on the teatime manners Professor Higgins has taught her.

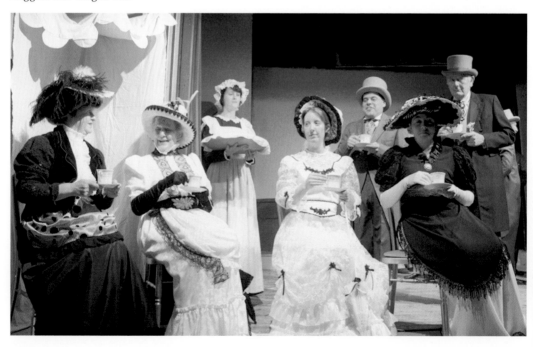

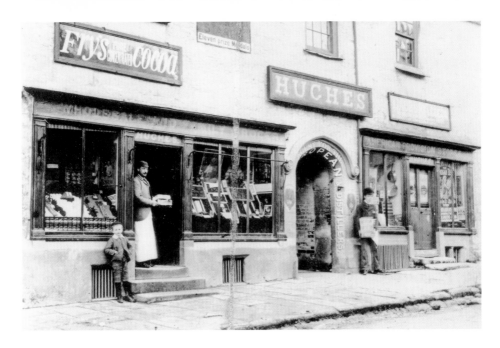

A High Street Grocery Store

Francis Charles Hughes ran his grocery business from premises near The Crown Inn in the High Street. At ground floor level much has changed: the windows have been altered, two doors blocked up and cellar ventilation grills bricked over. Only the fine Tudor doorway remains. What a transformation! The photograph of the shop is early, probably from the 1890s. Note the ankle length grocer's apron and the distiller's advertisement painted around the doorway.

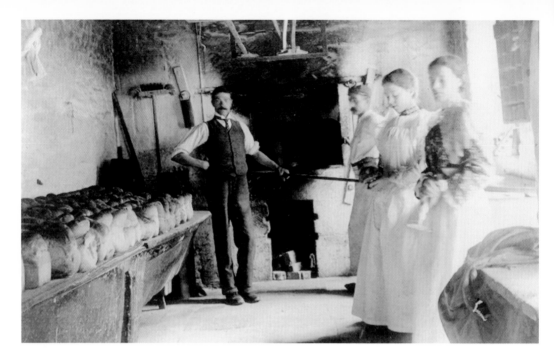

The Bakery

According to the 1910 Kelly's Directory of Gloucestershire, Jesse White had a bakery business in the High Street. The shop, it is believed, was what is now M and B Stores, next to the Market House. In the modern picture Mr Price, who works in the store with his wife, is seen in the doorway. The earlier picture shows where the bread was baked, in what is now a private house through the back of the shop and across a yard.

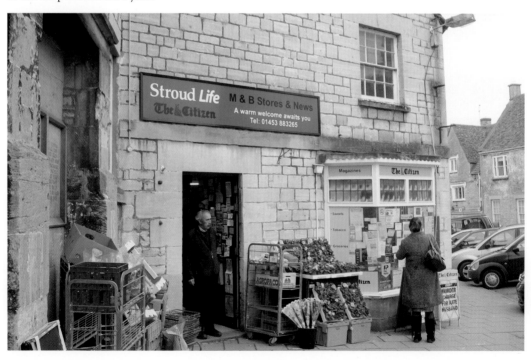

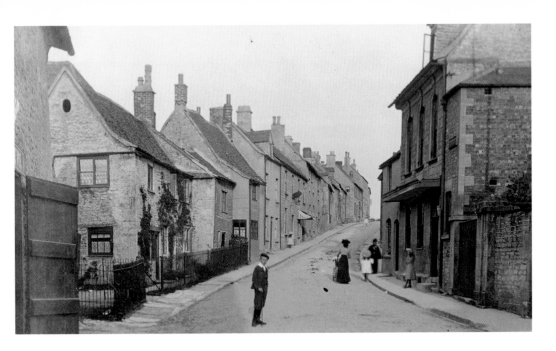

Lower Tetbury Street

For many decades the building on the right was Minchinhampton's post office. Following its recent closure as such, and thanks to the community spirit of the town's inhabitants, a new post office has been opened in the High Street. The premises on the extreme left were, a century ago, the blacksmith's shop of Jehu Shipway and Sons. Much of the rest of the street remains largely unaltered, a house on the right possessing some interesting early sculptural additions.

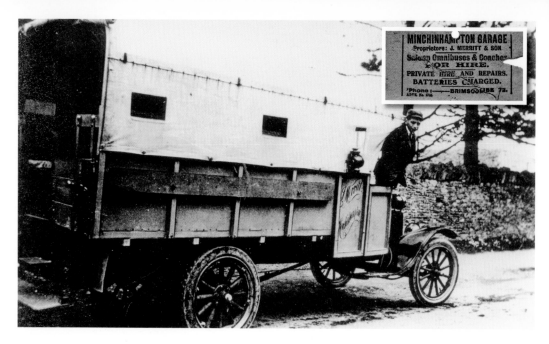

Public Transport, Then and Now

John Merritt inaugurated Minchinhampton's first motor bus service. The rather unlikely mode of transport in the top picture was, in fact, his first vehicle. The date of the photograph is 1921 and the conveyance is a 1 ton fourteen-seater Ford. The inset image shows an early ticket for this service. In the lower photograph a present day bus takes on passengers outside the Market House. Note the sign on the left for the long-closed Ram Inn.

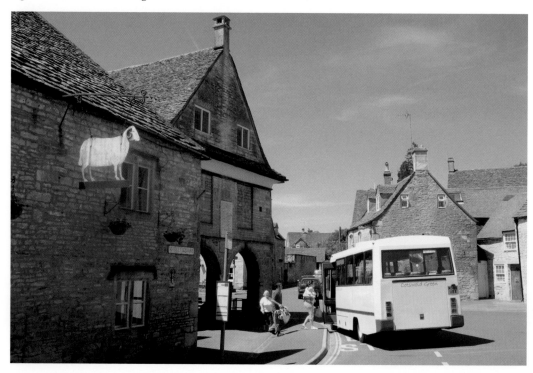

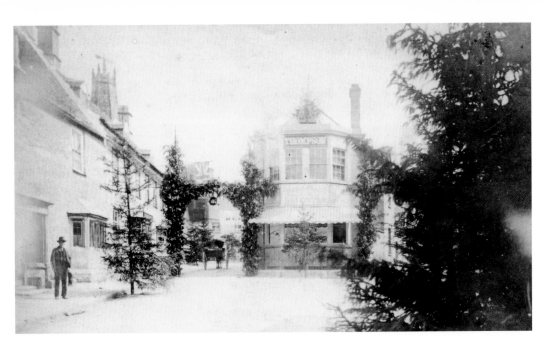

Golden Jubilees

The sepia picture must be one of the very earliest photographic views of Minchinhampton to have survived – or indeed perhaps ever been taken. It shows the largely arboreal decorations put up in the town for the Golden Jubilee of Queen Victoria in 1887. At this period James Thompson, draper and outfitter, occupied part of the Lower Island building. The companion photograph, taken from the opposite direction, is of street celebrations marking Elizabeth II's Golden Jubilee in 2002. A number of well-known Minchinhampton faces can be detected in the crowd.

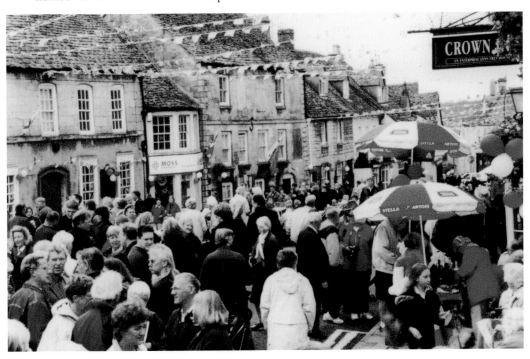

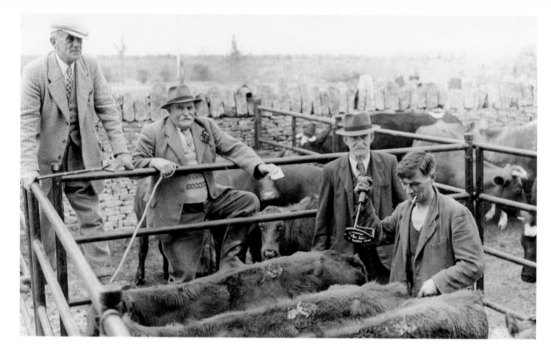

Marking Day

Commoners' Rights have been enjoyed at Minchinhampton for centuries. In former times these included cutting timber for fencing, collecting firewood, digging turf for roofing and quarrying stone. Since 1965 only grazing rights for cattle and horses remain. Animals are released in the late spring and recaptured in the autumn having, hopefully, avoided being involved in traffic accidents in the interim. The black and white picture shows Marking Day, when cattle were branded prior to release, about half a century ago. The modern image is of the last such occasion in the year 2000.

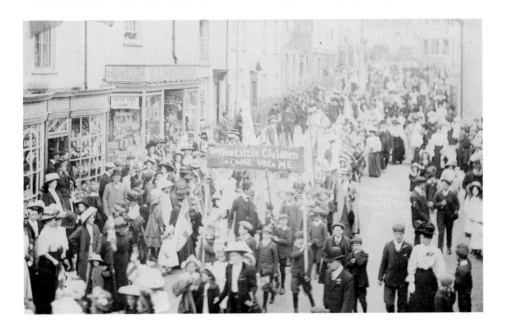

Baptist Processions

In Edwardian days there was great rivalry – often none too friendly – between Baptists and Anglicans in Minchinhampton. At Whitsun both communities held processions, the Anglicans on the Monday, the Baptists the next day. Each was followed by a treat for the children (clever youngsters, one hears, managed to participate in both). The sepia picture shows the Baptist procession of 1909 in the High Street, the black and white one a similar event *c.* 1955.

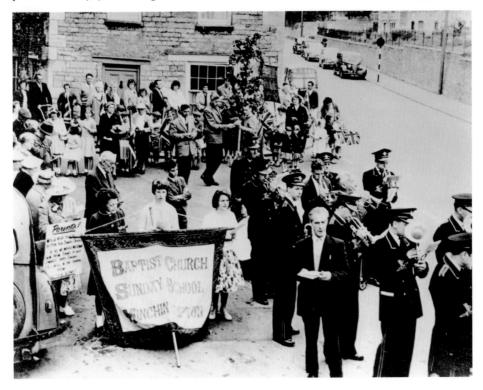

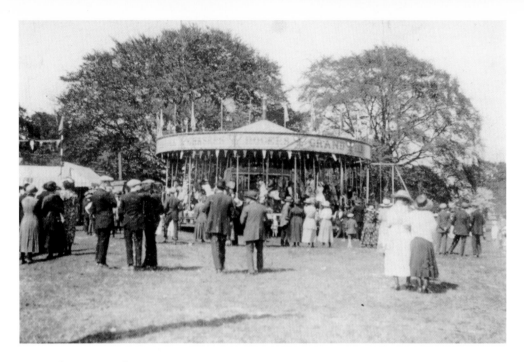

Entertainment on the Common

For many decades Rogers' Fair, held on the Common at the top of Bell Lane, was an event looked forward to by the young of the town and the surrounding area. The older picture was taken around the time of the First World War. The last such event the author attended was a visit a few years ago by Nell Gifford's Circus. The colour pictures show a friendly clown and the circus owner on horseback.

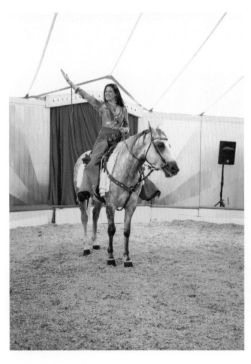

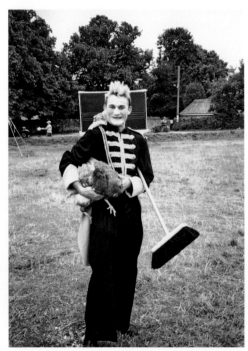

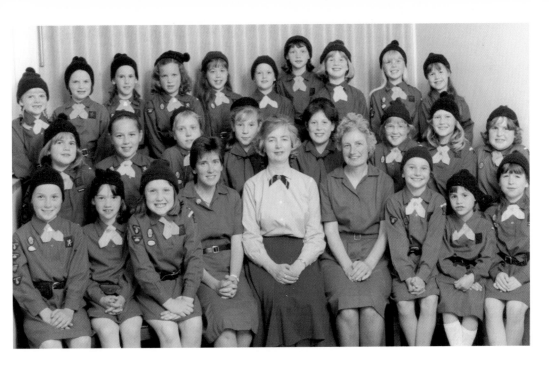

The Brownies

For a good many years Miss Alison Jones, who taught at the primary school, was involved in running the 1st Minchinhampton Brownies. She is seen here, on the right, together with Ruth Morris, left, and Mary Vanstone. The picture is thought to date from the late 1980s. In the lower picture a group of current Brownies – dressed very differently – prepare to go litter picking.

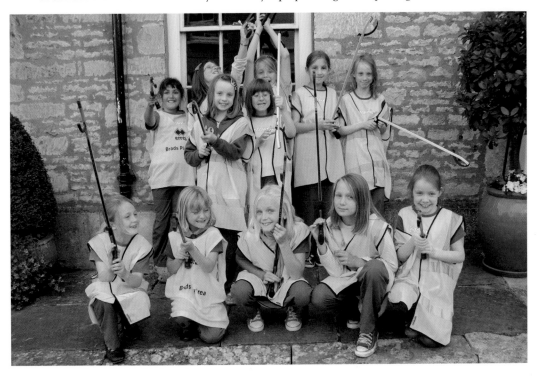

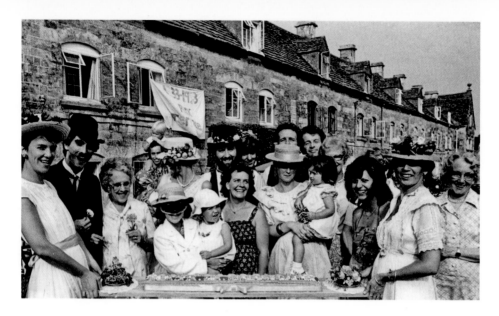

Park Terrace

Park Terrace was built for David Ricardo of Gatcombe Park in 1833, as date stones on each gable testify. The architect he employed, George Basevi, was probably the same as for his own house. The story goes that originally the tenants had only a front garden. One of Ricardo's family, when passing by, was offended at seeing washing hanging out, so rear gardens were subsequently provided! The black and white picture shows the party held in 1983 to celebrate Park Terrace's 150th anniversary.

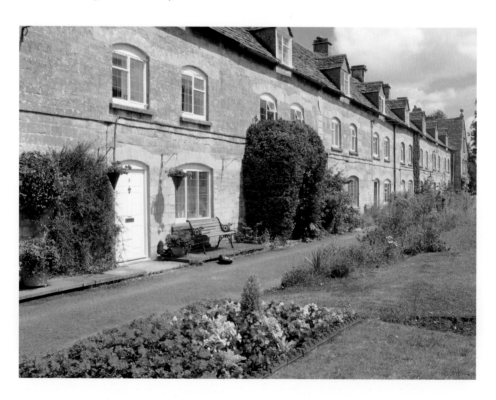

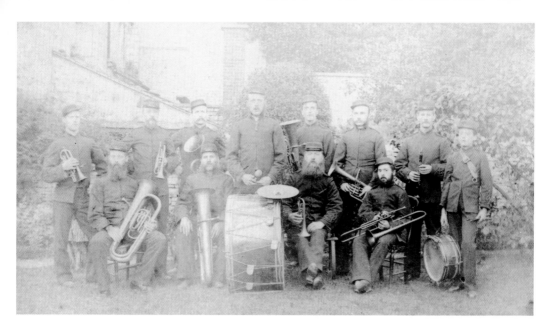

Bands

Much yellowed by age, the top picture shows the Minchinhampton Band in 1875. It was formed around 1860 and disbanded sometime in the 1920s. Because of the period of the photograph it has not been possible to put names to any of those shown on it. Since the Minchinhampton Band as such no longer exists, the companion photograph is of the Nailsworth Band, conducted by Minchinhampton resident, Trevor Picken, playing in the garden of 'Two Trees Corner', now 'Hunters Lodge', around 1976. Trevor is well-known locally, especially as he is the owner of a very rare Hampton Car, formerly made not far away at Dudbridge. The bandsman on the left is Fred Clark, who joined the Minchinhampton Band in 1898, aged eleven, and was still playing in 1977.

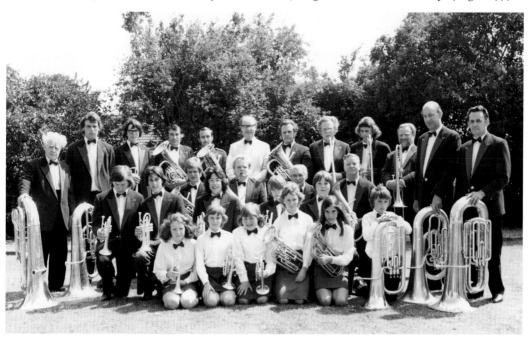

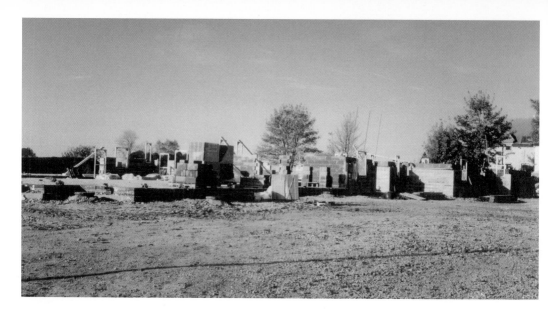

Horsfall House

The idea for building a nursing home in the town came from Dr Chris Booth as long ago as 1982. Funds were raised and land in Windmill Road was given by Miss Jean Horsfall, who laid the foundation stone on 21 September 1993. The completed building was opened by HRH the Princess Royal on 30 September the following year. Horsfall House originally comprised twenty-two nursing beds, with an additional eight for mentally infirm patients and a day centre. A wing was added in 1997, which considerably increased capacity and, in 2008, further expansion took place by which the Cotswold Unit was extended, given its own dining room and provided with a larger kitchen. A Home Care Unit was also built. Today the day centre operates six days a week and around ninety people attend it. The earlier photograph shows building work in progress.

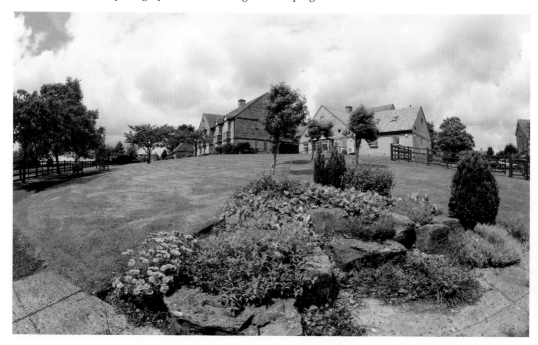

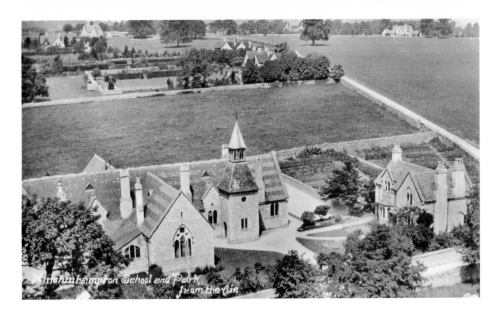

The Old School

Minchinhampton's former school building, with its distinctive bell tower, was erected in 1868. Many residents of the town will recall it and memories may include what is, by today's standards, the huge size of classes. Miss Dorothy Fassnidge, who taught there for many years, recalled that in 1966 Mrs Pamela Matthews presided over a class of forty-eight infants! About sixty youngsters stayed for school lunch, which was brought pre-cooked from Dudbridge and, in the 1970s, cost five pence a day. Successive head teachers lived in School House, visible on the right in both pictures and now a private dwelling. Harold Bosley was the last to do so. The school was demolished in 1968. In the modern picture note the housing development top left; also how trees obscure the present school buildings.

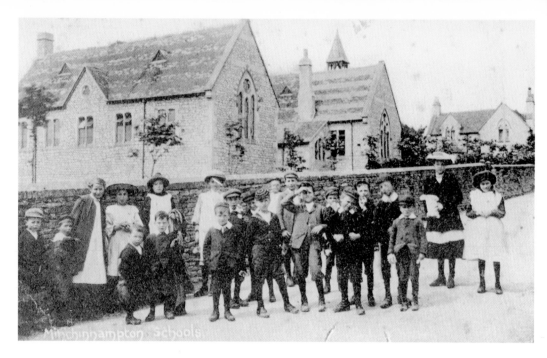

Pupils in Bell Lane

The old postcard shown here was franked in 1909, so is just about a century earlier than the lower picture, but how clothing has altered! There was no school uniform at Minchinhampton in those days. Edwardian parents would always have sent their sons off each morning with sturdy shoes, a jacket, broad collar and, of course, a cap. Older girls would wear stockings and bonnets, also pinafores, which were washed and mended as often as needed, to keep dresses clean. For the poor, mended or darned clothes were acceptable, but to arrive at school with an unwashed apron was not. By comparison, today's uniform is more practical.

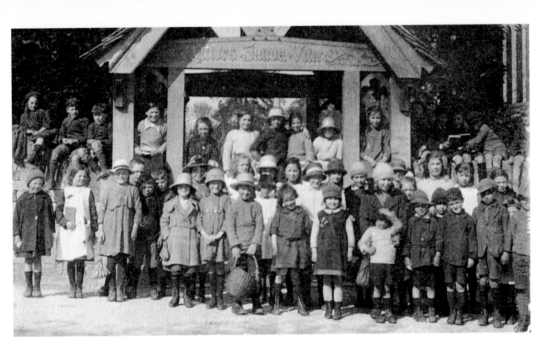

The Lych Gate

The author is indebted to the late Jim Lines, who died shortly before this book was compiled, for the charming photograph of a group of children, pictured around 1916 in front of the Lych Gate – itself only put up some eight years earlier. The Latin inscription on the crossbeam translates as 'Death, the Gateway to Life'. The present-day picture includes Rod Harris, the head teacher who retired just a day or so after it was taken. (He appears here at the author's insistence, as a mark of gratitude for the trouble he took in posing and photographing the children.)

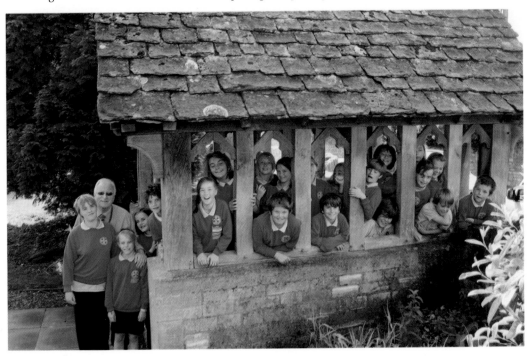

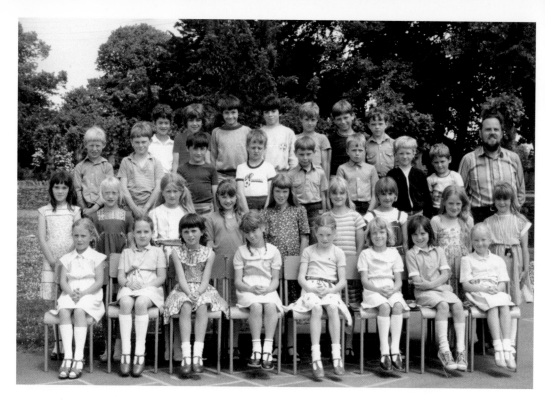

School Groups

For many elderly people, memories of school mean metal-framed double desks with inset inkwells and hinged seats, exercise books in which handwriting had to be kept scrupulously neat and tidy, inattention punished by chalk flying through the air and, of course, the cane! The author recalls receiving the latter for foolishly throwing a stone in the playground at nearby Thrupp School around 1953. The upper picture dates from his time as a teacher at Minchinhampton between 1976 and 1987. The lower one shows Minchinhampton Staff and school leavers in the summer of 2008.

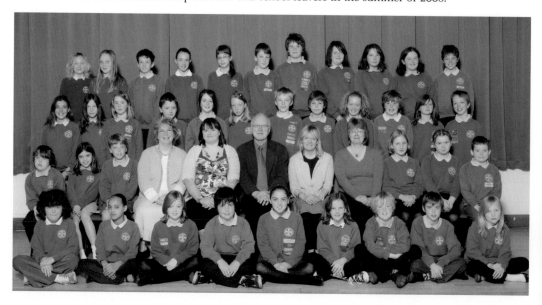

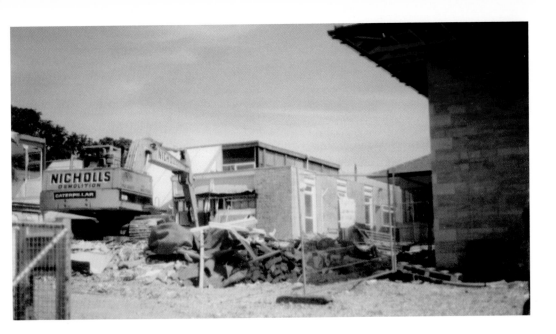

Demolition

As was stated earlier, Minchinhampton's Victorian school was demolished in 1968. It was replaced by Gloucestershire County Council with the S.C.O.L.A. Mark II – a building designed by a Nottingham firm. It was intended to house a two-form junior school, with an infant school to be built on a site behind the library. The latter never materialised and, instead, terrapin classrooms were placed on the school field to enlarge pupil capacity. At one time children were also taught in rooms in School House, vacated just previously by Harold and Kathleen Bosley. By 1988, however, many window frames in the main building had rotted, and rainwater frequently penetrated the flat roof, which had to be re-tarred several times. By the end of the 1990s, after a lifespan of only thirty years, demolition was inevitable and the new millennium saw the erection of a brand new structure. The upper picture shows a bulldozer at work, with part of the present school building already standing nearby. The lower photograph is taken from the same spot in 2009.

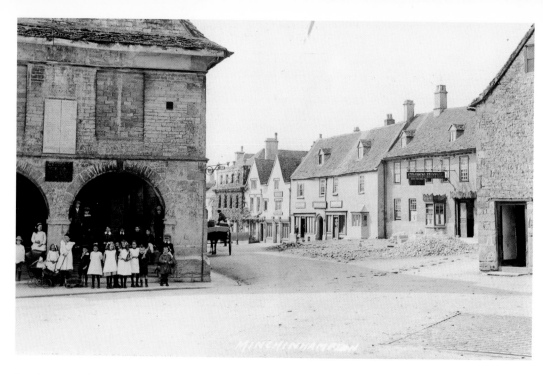

Further Demolition

Around 1920 the buildings of Lower Island were removed. The top photograph is interesting because it shows a large pile of rubble still marking the site. The photographer was clearly impressed by the vista Lower Island's removal revealed and persuaded local children to line up for him by the Market House. In the second photograph Mr Harris has carefully positioned his pupils similarly.

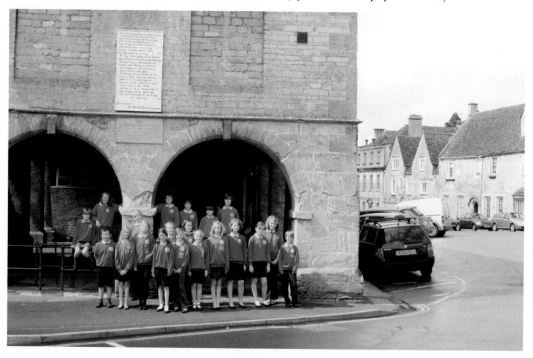

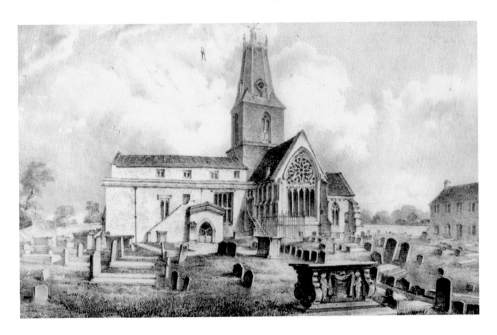

The Parish Church

In 1838 J. P. Brinsley published his grandly named *Twenty Lithographic Views of Ecclesiastical Edifices in the Borough of Stroud.* These were based on drawings by Stroud artist Alfred Newland Smith. The engraving reproduced here shows the church as it was before the nave was rebuilt in 1842. The modern picture could not be taken from the same position, since Smith employed fairly large helpings of artistic licence in his foreground. The later photograph also shows the Porch Room, added on much later in 1973.

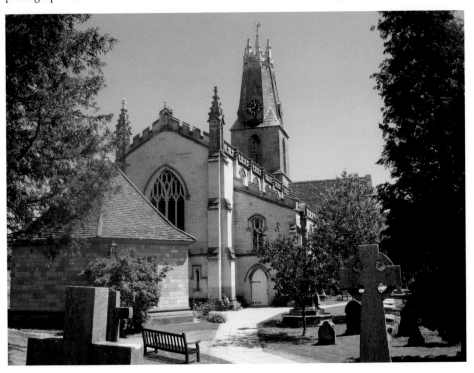

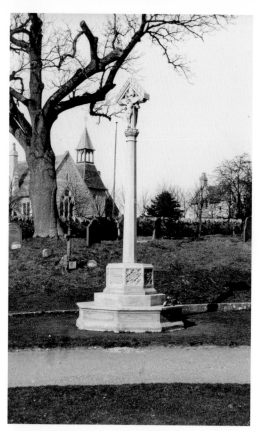

The Churchyard Cross

The memorial churchyard cross had not long been erected when this picture was taken in the early 1920s. In 1973 it was moved further away from the church when the Porch Room was put up. Beyond the graveyard wall may be glimpsed the Old School and School House. In the colour picture Miss Gladys Beale is seen making her way into church for a Sunday morning service. She reached her 102nd birthday during August 2009. For many years Miss Beale ran a small private school at Blueboys Corner, which takes its name from a former inn nearby, traceable back to 1718. Its sign is preserved in Stroud's Museum in the Park. 'Blueboys' derives from the dye workers who were employed locally in the cloth trade.

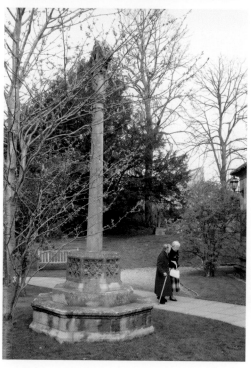

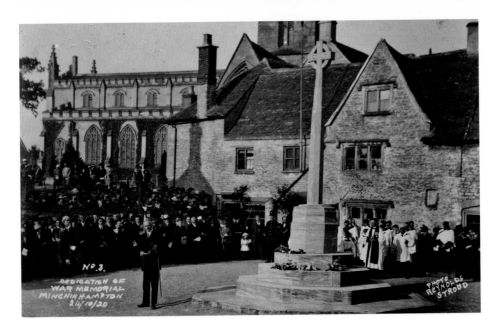

The War Memorial

Built on the open space available following the demolition of Lower Island, the war memorial was dedicated on 24 October 1920. Three generations on, it is difficult for us to appreciate the poignant significance of this event. All those attending the ceremony must have had fond memories of many of the men whose sacrifices the monument records. E. O. Reynolds from Stroud took a series of commemorative pictures of the occasion. He was one of a century-old chain of photographers operating from Peckham's premises in Russell Street, Stroud. Sadly the firm has now closed. The picture shows Major H. G. Ricardo, of Gatcombe Park, addressing the crowd. It is gratifying to see how well maintained the memorial is today.

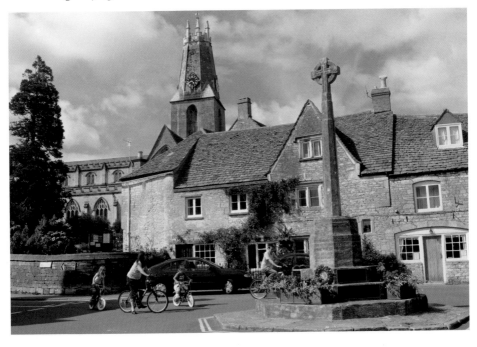

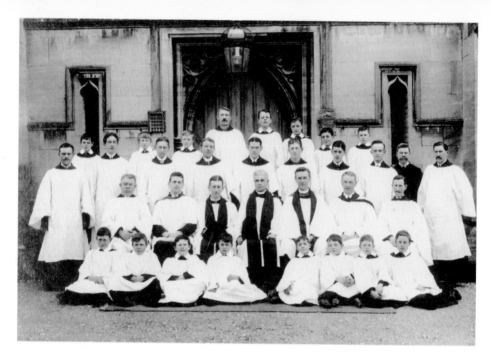

The Church Choir

Minchinhampton Church has always enjoyed a tradition of fine choral music, provided both by its own choir and by visiting groups and soloists. Concerts take place in the building on a regular basis, at least one each year given by the Cappella Singers and many by the Stuart Singers. The older picture shows the church choir, possibly around 1920. They are photographed where the Porch Room is today. It will be noted that the group consists entirely of men and boys. By contrast, the cheerful, smiling choir of 2003 is made up of both sexes.

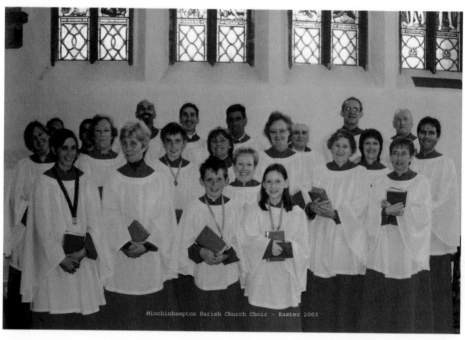

Minchinhampton Parish Church Choir - Easter 2003

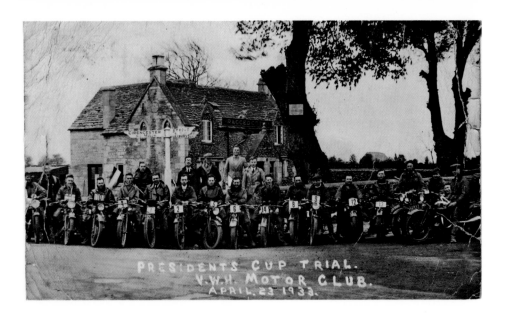

The Ragged Cot

Presumably named after the rusticated stone used to enhance its exterior, this hostelry has a long history. Charles Townsend is recorded as the landlord in 1880, and by the 1930s when the black and white photograph was taken Harold Cox was the tenant. The picture is of more than simply local interest since it records a visit by a Wiltshire motorcycle group, The Vale of the White Horse Motor Club, on St George's Day 1933. Over the years The Ragged Cot has been extensively redeveloped at least twice, the last occasion being in 2007.

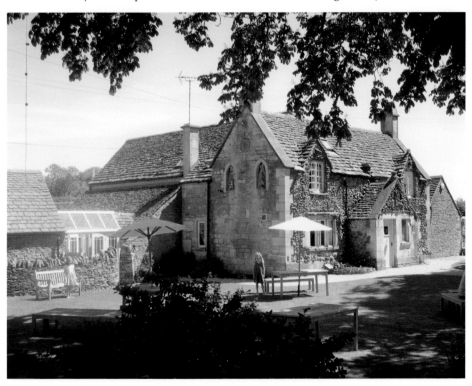

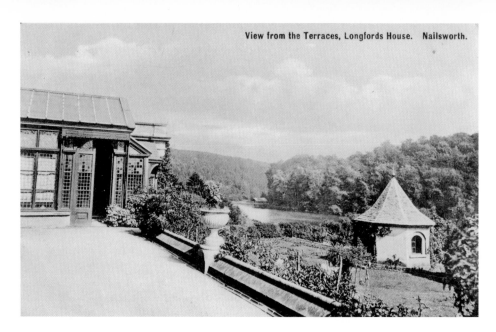

View from the Terraces, Longfords House. Nailsworth.

Longfords

The Longfords Estate and Mill were acquired by the Playne family around 1800. Shortly afterwards they built themselves a fine residence overlooking the mill and the lake – the latter being fifteen acres in extent and completed in 1806. A generation later two wings were added. Over the last few years, since the mill ceased production, its factory and ancillary buildings have been converted for residential use. For many years after the last war the house itself was a girls' school and is now the home of Stroud Court Community Trust. The terrace and summerhouse survive, but the view to the lake – which the builders of Longfords House intended to be seen – has become obscured by trees.

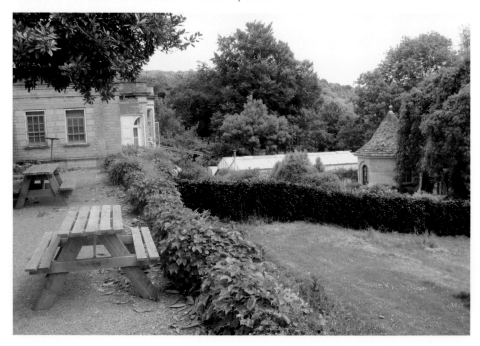

The Halfway House

Built, as its name suggests, halfway between Nailsworth and Minchinhampton, this is another long-established inn, first recorded in 1779 and then known as The Crown and Crescent. During childhood, when his family lived at Thrupp but had no transport, the author well remembers taking a single-decker bus to Tom Long's Post on fine summer afternoons, walking across the Common past the Halfway House, enjoying a simple picnic under a large beech tree at the top of the 'W', then dropping down into Nailsworth to visit elderly great-aunts who kept a small shop selling boot polish and laces. The return journey involved two further bus rides.

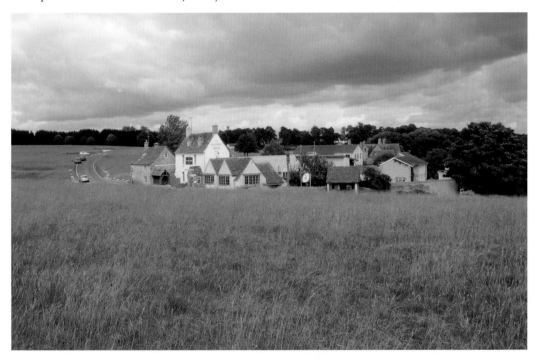

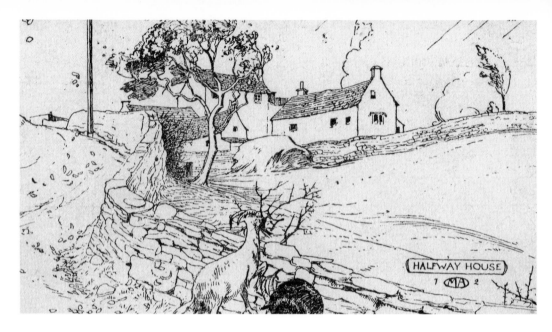

The Halfway House, Rear View

Artist-drawn postcards of the area are not uncommon. Some are one-off amateur sketches sent to friends, others, like this example, are by semi-professional hands. The initials M.A. stand for Maxwell Armfield, who produced several other local postcard views in the period just prior to the First World War. Armfield is best remembered as the official artist for Stroud's largest ever community event, the splendidly named Mid Gloucestershire Historical Pageant of Progress, which involved a cast of some 1,100 participants and was staged at Fromehall Park in the summer of 1911. This grandiose drama, portraying the area's part in history through the ages, included an orchestra and, for the medieval episode, a flock of sheep! In the modern photograph, note the recent extensions to the property.

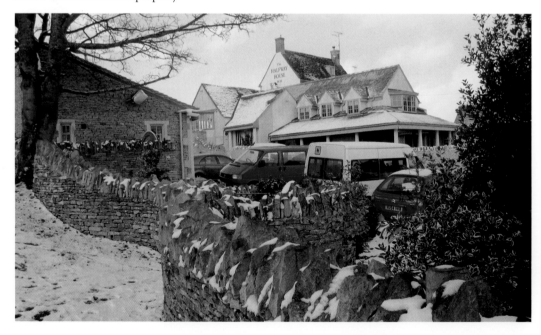

Box (1), View from Minchinhampton Common near Stroud.

Box Village from the West

Houses and the village hall now occupy the large open field seen in the Edwardian postcard, published by the firm of Tomkins and Barrett of Swindon. The gardens, or allotments, to the right of it are now a car park. Most of the early buildings in Box survive, many lovingly restored with attractive gardens. Present day tree growth, however, prevents them being seen in the modern picture.

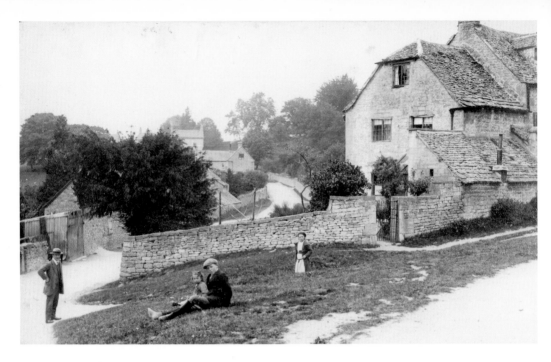

Looking towards Box Green

The house in the foreground now has a more conventional roof line, while shrubs in its garden prevent one seeing the road leading down to, and beyond, the Green. The grassy corner at the front of the picture has partly disappeared and, with it, the possibility of re-creating the charm of the earlier image: double kerbing and a grit bin can hardly compete.

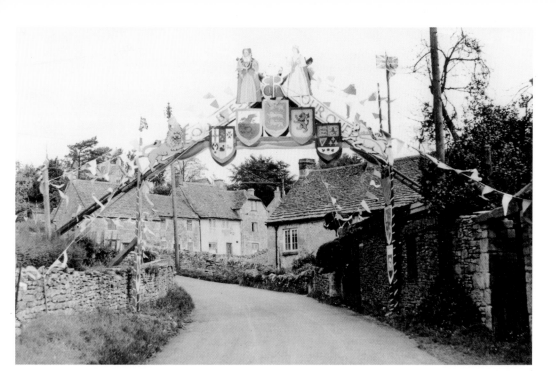

From Box Green, Looking East

As far as the buildings in these pictures are concerned, very little has altered over a half century or so, with the exception of the erection of a garage on the right. Interest lies in the decorative arch put up in June 1953 to celebrate the Coronation. In front of the message, 'God bless our Queen', are various royal coats of arms, the ER II monogram and painted images of both Queen Elizabeth I and II. Flags further enhance the scene.

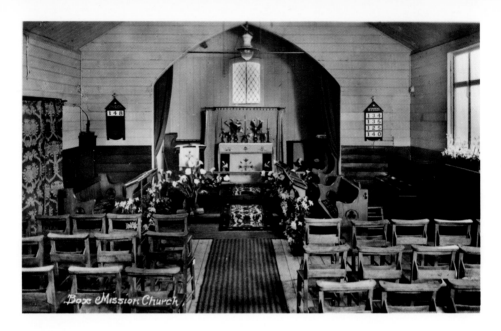

Box Church

Box Mission Church, seen in the earlier picture, was a wooden building put up sometime before 1897. After the last war it was decided that a more permanent structure should replace it and the Bishop of Gloucester laid its foundation stone on 8 December 1951. The church was built in local limestone by J. Simmonds and Sons of Minchinhampton, to a design by architect Peter Falconer of Stroud. Stained glass was by Box artist, Edward Payne, 1906-1991. The pictures show two very different interiors.

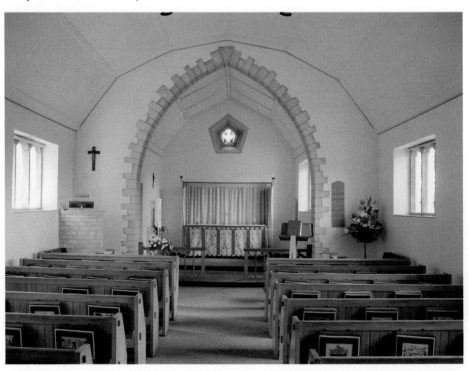

Hampton Road, Box

In this view looking west through Box village, once again the problems posed by trees in re-taking an Edwardian view become apparent. It has also to be said that telegraph poles and wires do little for a photograph. The later picture shows tarmac replacing road-stone and tall hedges affording privacy, but obscuring views. The building nearest to the camera also illustrates the modern tendency to remove cement rendering and pebbledash.

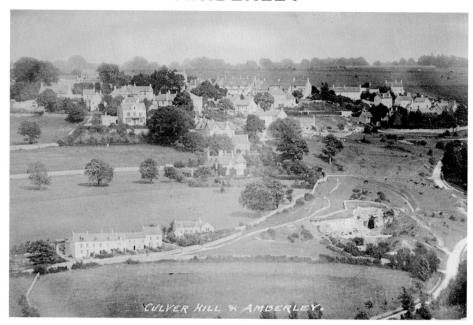

CULVER HILL & AMBERLEY.

Amberley from the South

This pair of photographs offers an interesting contrast. Once again trees predominate in the modern view, completely obscuring Culver Hill and the stone mine so obvious at the bottom right of the sepia photograph. Recent housing provides the other noticeable difference, especially in the bottom left corner. The two images are worth comparing in detail. The early one was taken by Mark Merrett, who had a photographic studio in Stroud.

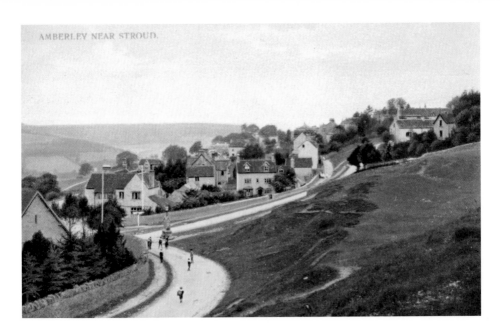

The Amberley Inn from the Common

This hostelry was first recorded in 1855 and enlarged in 1926. On the back of the postcard shown here is written simply, 'My present resting place'. It was sent to Australia around 1910, was produced by a nationally active firm, F. Hartmann, and was clearly hand-tinted by some employee who had never been near the Cotswolds - hence his decision to give the village orange pantiles! Incidentally, children today would be unwise to play where their predecessors of a century ago did.

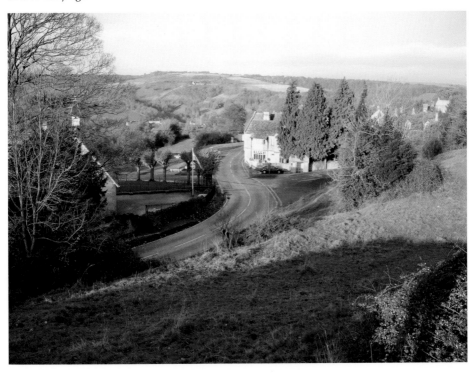

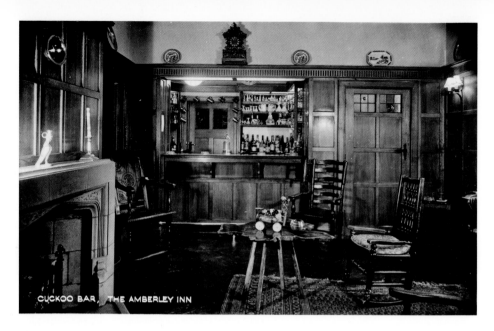

CUCKOO BAR, THE AMBERLEY INN

The Bar at The Amberley Inn

The Amberley Inn is a traditional Cotswold hotel, well positioned at the edge of Minchinhampton Common. The panelled interior of the bar creates a warm, hospitable atmosphere, evidently appreciated by the gentlemen enjoying a lunchtime drink. Apart from the addition of a mirror over the fireplace and a larger table, other differences really amount to no more than a change of ornaments in the room.

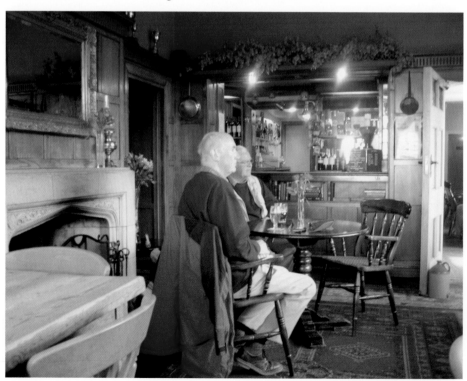

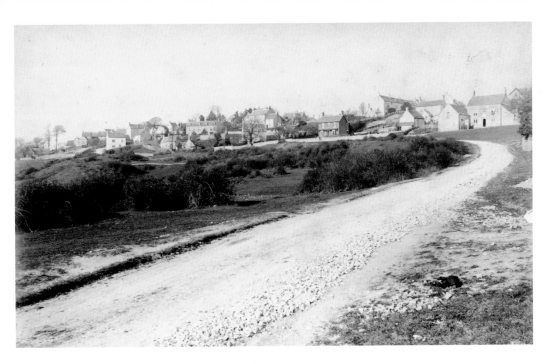

A Distant View of The Amberley Inn and the Village

The sepia picture shows The Amberley Inn before the major alterations which so changed its frontage. This image is from the camera of Paul Smith, 1845-1932, who was a science teacher, but also operated semi-professionally as a photographer. He was based in Stonehouse during the 1880s. This picture comes from his later period, roughly 1890-1902, when he lived in Nailsworth. Note the extremely rough surface of the road as it passes down the side of the graveyard.

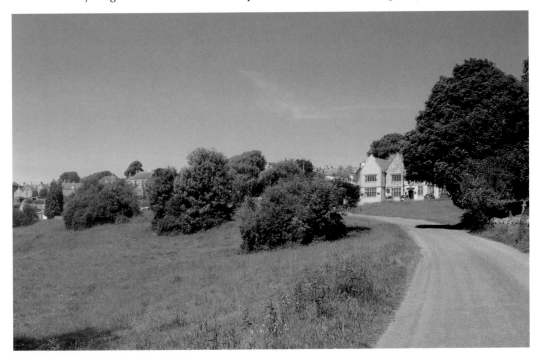

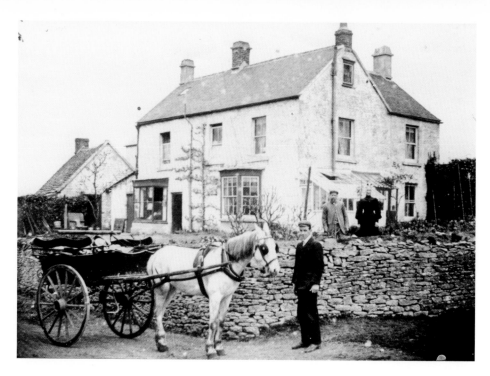

The Old Bakery

George Matthews was Amberley's baker from roughly 1885 to around 1906. On the original photograph his name is just visible on the delivery cart. The picture comes from an important group of images owned by Margaret Gardner, MBE. The picture shows how people, vehicles and animals can bring a scene to life. The bakery today is divided into residential properties. Note the extension now built on the near end of the building.

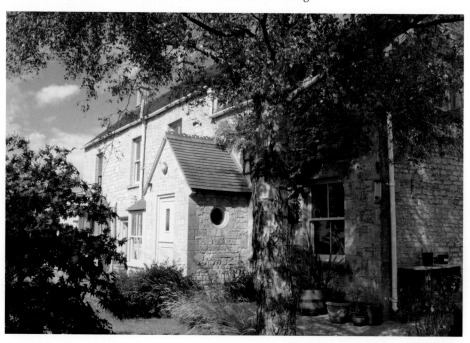

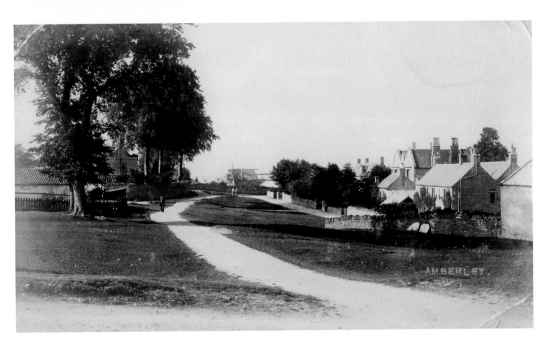

Upper Littleworth, Looking South

When comparing photographs dating from a century apart it is normal to see roads formerly surfaced with road-stone now covered by tarmac. Here, the opposite seems to have happened and grass has grown down the centre of the track. Some of the buildings to the right cannot be seen today because of a large, but very attractive, copper beech tree. The roadway in the distance leads off to the right towards The Black Horse public house.

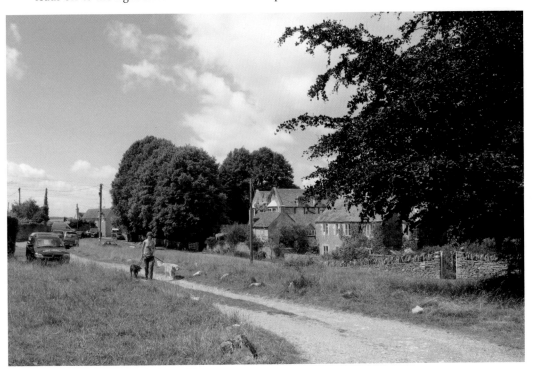

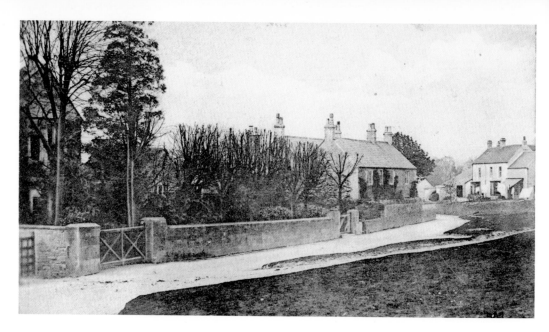

Upper Littleworth, Looking North

The Old Bakery may be seen far right in the older picture. Part of the gabled frontage of The Deyne appears on the extreme left and, next to it, Deyne Cottage, the premises that were Amberley's early post office. The building, as photographed by Paul Smith around 1890, featured in the author's book *The Nailsworth Valley*, published in 2005. Because this cottage once housed the post office, the contrasting picture chosen is of Amberley's present equivalent, situated on the hill leading down to The Amberley Inn.

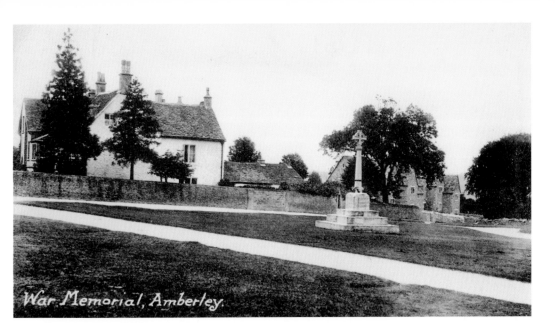

War Memorial, Amberley.

The War Memorial

The building to the left of the war memorial was formerly The New Lodge coaching inn, opened in 1843 and so-called to differentiate it from The Old Lodge across the Common. The New Lodge is now divided into two parts; the nearer, behind the conifers seen in the older picture, is called Springfield. The ceremony of dedication of Amberley's war memorial was covered by E. O. Reynolds, the same photographer who attended that in Minchinhampton. For Amberley he created a series of at least eight postcards. The pure white road surfaces in the sepia picture are worthy of note.

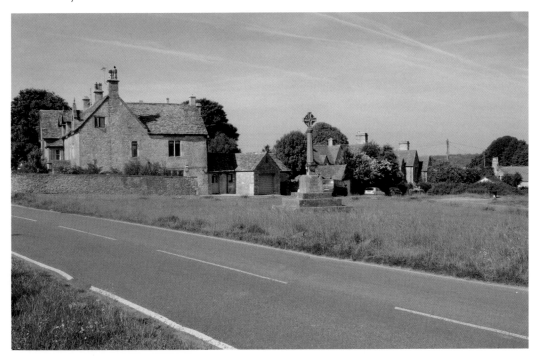

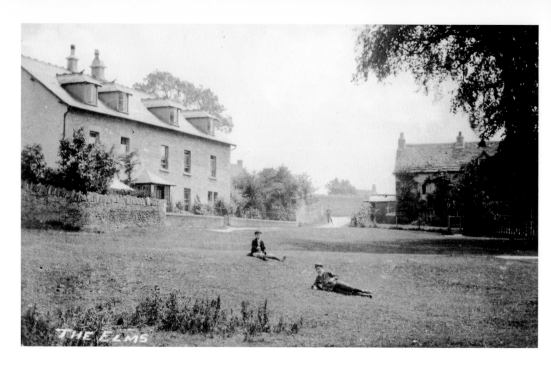

The Elms

Boys relax on the grass in the picture taken around 1910 by Stroud photographer Mark Merrett. Their modern counterparts return home from school past the same spot. Captioned by Merrett 'The Elms', the left end of the terrace is today called Grayling House and the further part Elm Cottage. Present day yew trees conceal the building visible in the earlier photograph.

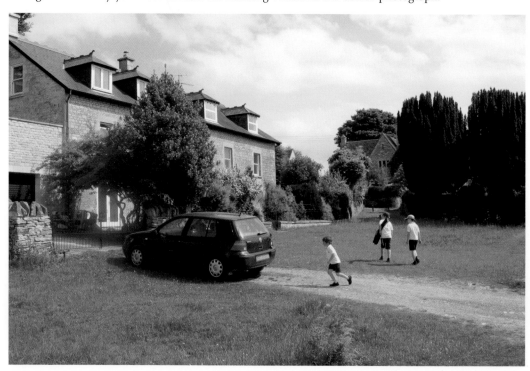

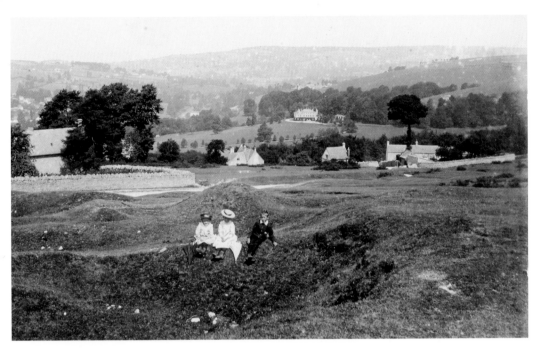

A Distant View

As a foreground for his picture of *c*.1895, Paul Smith chose three children out for a walk on the Common near where the war memorial now stands. One might add, poignantly, that the boy in question would almost certainly have taken part in the First World War when a young man and may be recorded on the monument. His young companions, wearing hats and high lace-up boots, have placed their parasols on the grass nearby. In the lower view, a modern photographer sits pensively on a bench, contemplating the trees which obscure much of the background visible a century earlier.

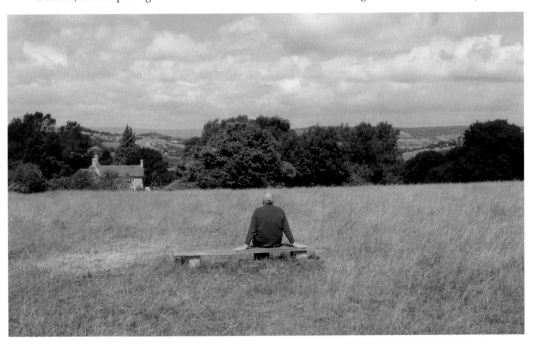

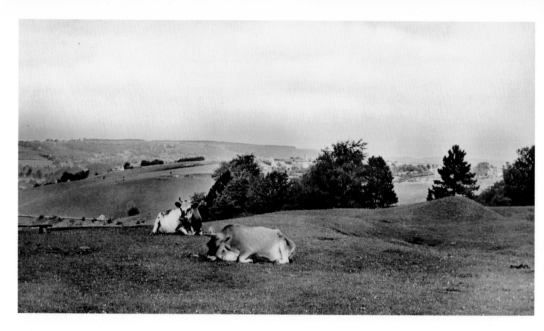

Cattle on the Common

The 1930s picture of cattle, taken by Stroud's pre-eminent photographer of the period, Edwin C. Peckham, is pleasingly composed. Peckham's images are of a universally high quality and some feature Stroud's 1935 Silver Jubilee celebrations for George V and Queen Mary. An even finer set depicts shops in the town, while others chronicle how the Second World War affected the district. In the modern view cattle lie peacefully at approximately the same spot. Several have clearly noticed the approach of the author.

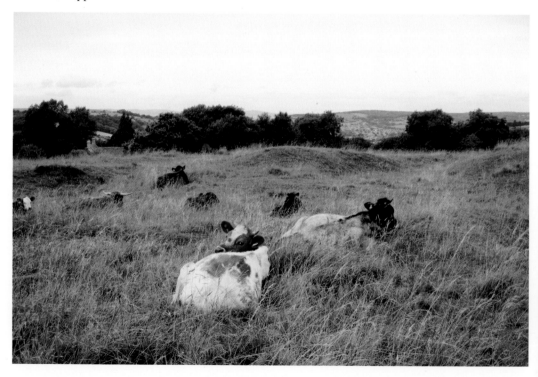

The Hawthorns

When the sepia photograph was taken, around 1905, William P. Niblett lived at The Hawthorns, which probably dates from the early eighteenth century. It was once a farm and was auctioned as such in 1908, complete with a dairy. The man behind the cattle in the road, so an informant has stated, was William Joseph Shipway. During the 1960s The Hawthorns was run as a hotel by the Offord family. Many wedding receptions were held there, including the author's in 1966. Interestingly, at some time in the last forty or so years the gables have been reduced from five to three. A house and garage have also appeared next door.

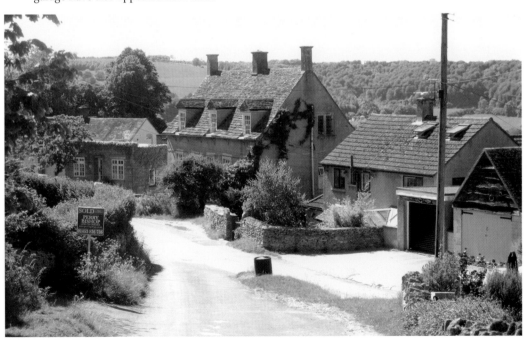

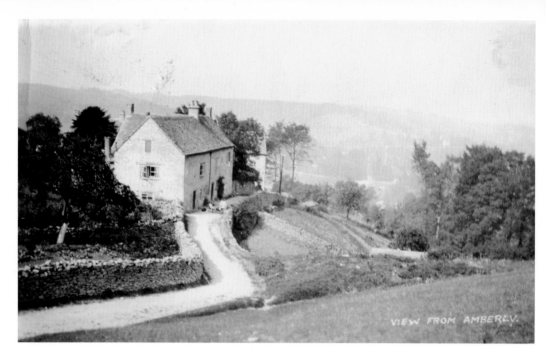

St Chloe

The postcard shown here was sent in 1922. It includes a short message: 'Coming tomorrow if fine, if not Thurs – Edie'. Several houses have since been put up nearby and – as is usual – there seem today to be more trees and bushes. Was it, perhaps, that formerly wood was needed to feed cottage fires and hence fewer trees were allowed to grow to maturity? Note the mis-spelling 'AMBERLY'!

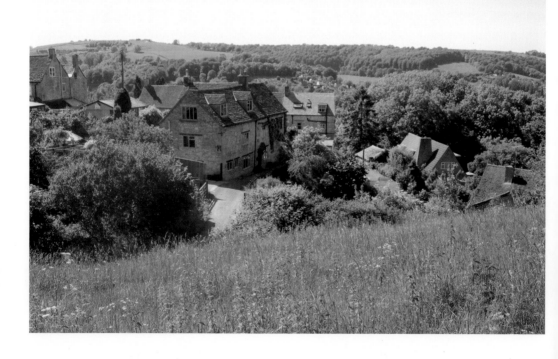

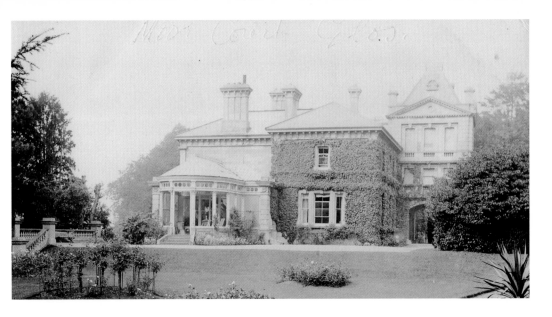

Moor Court

Moor Court was originally a farm named Mugmore and is first mentioned in 1747. Much enlarged and rebuilt in the mid-nineteenth century, it was renamed Moor Court. For many years it was the home of Lord Charles Pelham Clinton. It later became the residence of Mrs Sydney Allen before being sold to the England family, who ran it as a hotel. The author and his friends used to visit it each Christmas whilst carol singing in the area and benefitted from Mrs Beatrice England's hospitality. Since 1975 it has been subdivided and several additional properties put up in its grounds. The two pictures, a century apart, show it from the east.

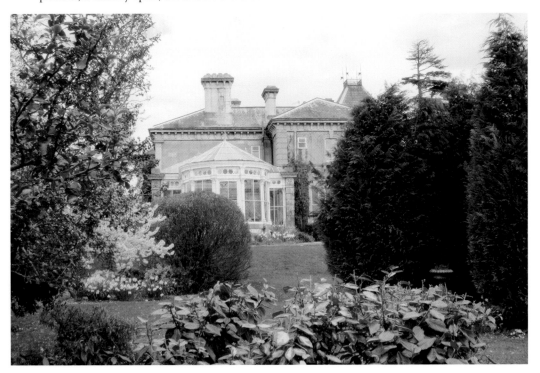

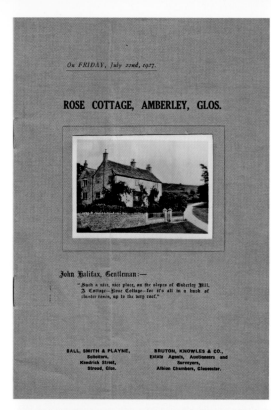

On FRIDAY, July 22nd, 1927.

ROSE COTTAGE, AMBERLEY, GLOS.

John Halifax, Gentleman:—

"Such a nice, nice place, on the slopes of Enderley Hill,
A Cottage—Rose Cottage—for it's all in a bush of
cluster roses, up to the very roof."

BALL, SMITH & PLAYNE,
Solicitors,
Kendrick Street,
Stroud, Glos.

BRUTON, KNOWLES & CO.,
Estate Agents, Auctioneers and
Surveyors,
Albion Chambers, Gloucester.

Rose Cottage

Rose Cottage, in its picturesque setting and with its stylish gothic windows, is perhaps Amberley's most well known building. The cottage was made famous as the house where, in 1856, while staying as a guest of the Guild family, Mrs Craik – real name Maria Murlock – wrote her famous novel *John Halifax, Gentleman*. The sales catalogue of 1927 is chosen as the earlier picture of Rose Cottage. In it the property is described as follows: 'A charming small stone-built residence in a beautiful district, about 550 feet above sea level, on the edge of Amberley Common, overlooking the Woodchester Valley'. It apparently then contained three sitting rooms, eight bedrooms and a walled garden of half an acre. Later it was a guesthouse and today, privately owned, its exterior is still admired by visitors who appreciate its literary connections.

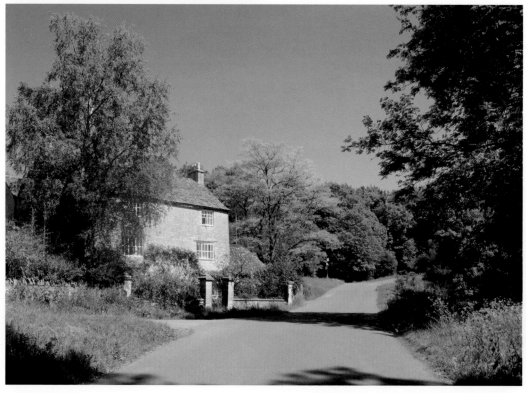

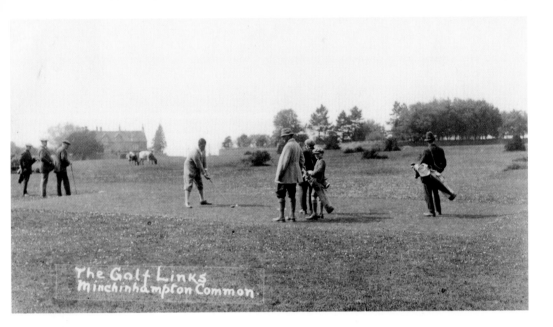

The Golf Links
Minchinhampton Common

Golf Again

Three golfing views are included in this book. Two appear in the earlier Minchinhampton section and the third one is inserted here since it shows Amberley buildings. W. H. Adams of Rodborough was the photographer of this picture. Adams' work for the G. P. O. provided this talented man with multiple outlets for selling his postcards through a number of sub-post offices he visited throughout the district. The image reproduced here dates from around 1925 and shows golfers, resplendent in plus fours, at what is now green number six near Amberley War Memorial. In the second picture current enthusiasts are seen at the same green.

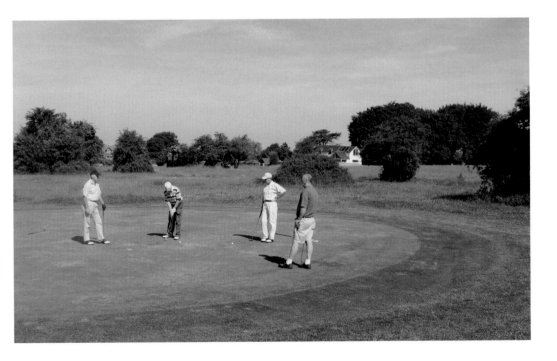

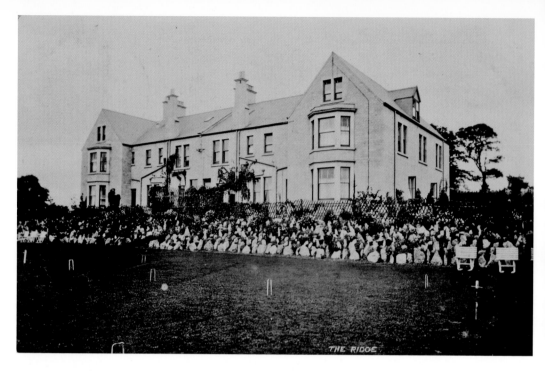

Amberley Ridge

When the earlier picture was taken a century ago, Amberley Ridge was run as a fashionable hotel by a Mrs Rosanna Thompson. Advertisements for the property make much of its supposed healthy qualities – fresh air and an elevated position. Note the well-manicured croquet lawn seen here in 1905. Since 1953 Amberley Ridge has housed a residential special school, whose pupils no doubt also benefit from an unpolluted atmosphere and the Common nearby.

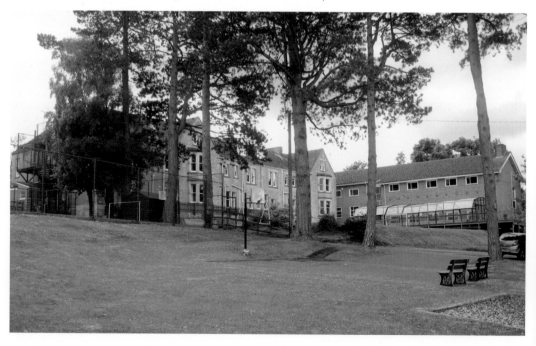

Theescombe House

This fine building, now no longer standing, was first recorded as the home of Nathaniel Clarkson, Amberley's churchwarden from 1836 to 1843. It was later lived in by Charles Playne, JP, son of mill owner Peter Playne. During the Second World War it housed St George's, a boys' Prep School, evacuated from Eltham in south-east London. The school consisted of thirty-five to forty pupils. The building, eventually falling into dereliction, was demolished and replaced by an estate of private houses. This information on Theescombe House was taken from *Amberley, a Village of Parts* by the late Roy Close, who was extremely well versed in all matters concerning the history of the village. The earlier photograph was taken from the south, the later one from the east.

A Talented Artist

For several years the artist Terry Thomas, who died just a decade ago, lived at Lamb Inn Cottage in Amberley with his wife, Joyce, a former colleague of the author at Minchinhampton School. Terry possessed a genius for artistic design and, in this cartoon-like seasonal drawing Terry and Joyce greet the world from an attic fanlight of their home. Much of Terry's painting was in his preferred medium – watercolour. In Autumn 2009 an exhibition of his work is to be staged in Minchinhampton to celebrate his artistically creative life.

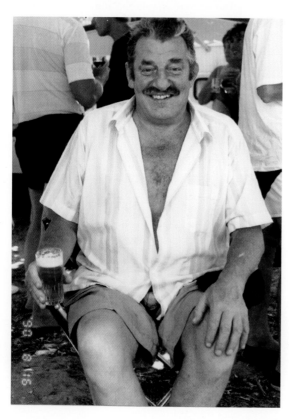

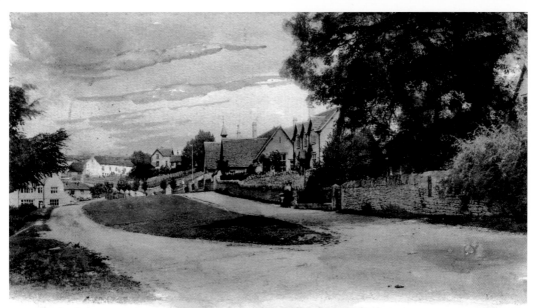

Amberley.

The Green and the School

School sports and playtime activities have traditionally taken place on this area of grass in front of the school building. The triple gabled property visible next to the school in the earlier picture was formerly the home of successive head teachers. The reason for selecting this postcard was the over-enthusiastic hand tinting indulged in by its unknown publisher. It was sent in 1904. Today it is difficult to photograph the scene with even as few cars present as the modern picture shows.

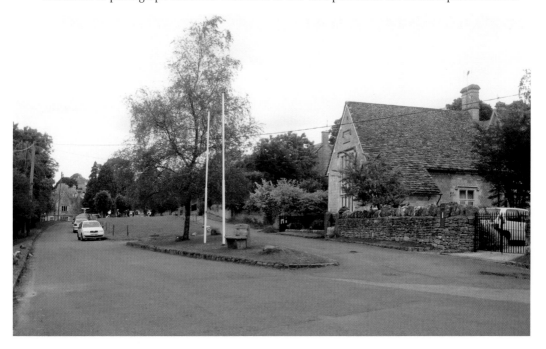

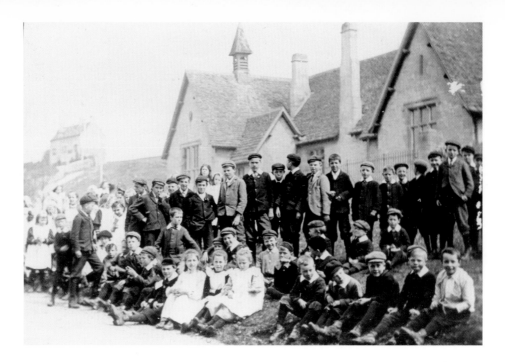

Amberley School

The place is the same; the school buildings appear identical but – just as in the case of the Minchinhampton School pictures – how differently the pupils are dressed. Gone are the heavy jackets and thick cloth trousers; how much more sensible are the lightweight school uniforms of today. The author is grateful to Amberley's head teacher, Peter Godfrey, for allowing his entire school to pose as a modern counterpart to their fellow pupils of around 100 years ago.

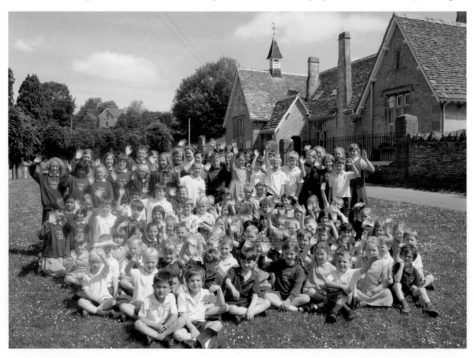

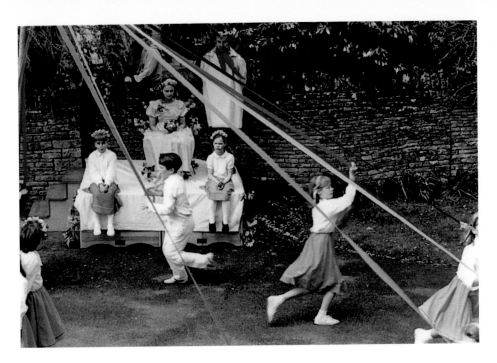

Maypole Dancing at Amberley

The upper picture was taken on the occasion when the village celebrated the opening of a new playground behind the church on May Day 1989. Country dancing at this time was organised by Mrs Maureen Anderson, who taught for many years at Amberley. She was also instrumental in preserving and classifying a host of pictures and documents concerning the school. The lower picture was taken at the 2009 summer fête.

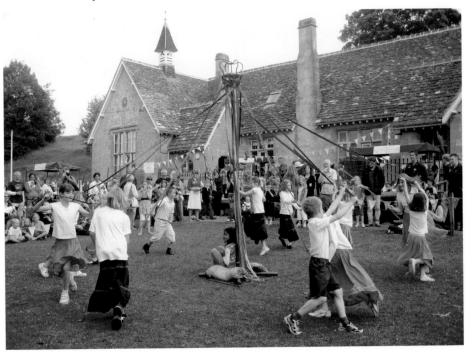

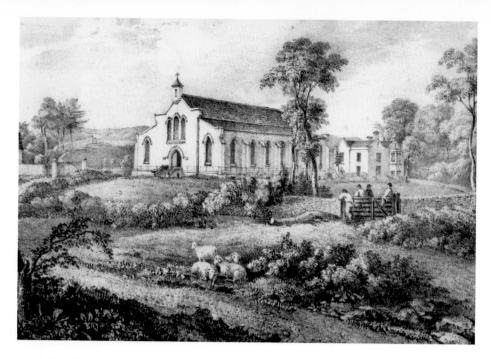

Amberley Church

In 1840 Amberley Parish was formed as a new ecclesiastical district from portions of Minchinhampton and Rodborough. The church building itself had been put up in 1836, to a design by Sidney Gambier Parry, the cost being defrayed by David Ricardo of Gatcombe Park. It is dedicated to the Holy Trinity. Alfred Newland Smith's engraving of 1838 shows the church in what might be described as a rather rustically enhanced landscape, with the original rectory to the right. The little bell turret became unsafe and was taken away in 1950. It was replaced, as the modern picture shows, by a simple cross.

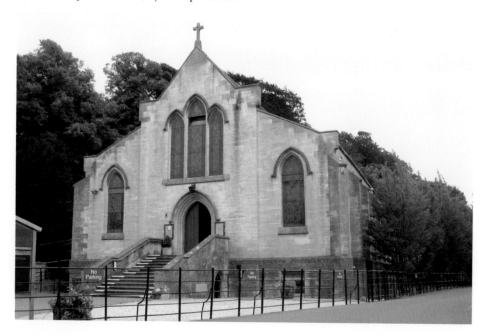

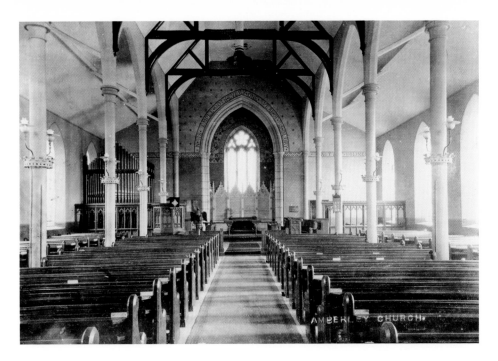

Amberley Church Interior

The sepia picture of the interior of Amberley Church is almost exactly a century old. Superficially little altered, on closer examination significant differences between the two photographs emerge: the original reredos and wall paintings have gone and in 2004 a beautifully embroidered frontal – the work of Amberley's clergy and parishioners – was installed; gas lights around the pillars have been superseded by suspended electric lights, a false ceiling has been put in and the organ pipe work radically altered. In both pictures the light, airy atmosphere of the building is evident.

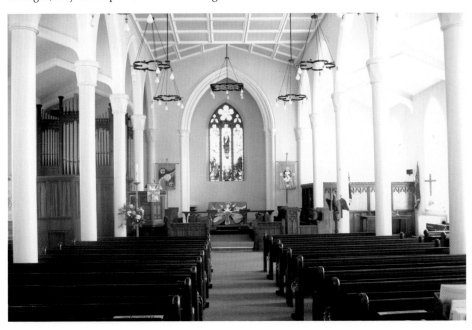

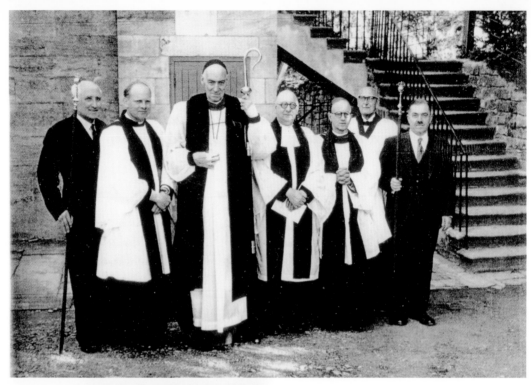

The Clergy

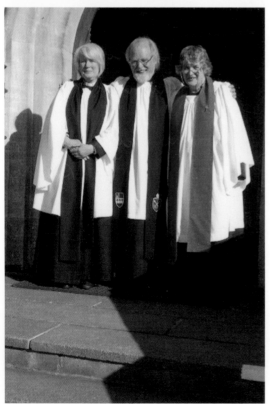

The black and white photograph shows the induction, in September 1959, of Revd A. Maltin as rector of Amberley. Those pictured are, from left to right, Capt. N. V. Grace (churchwarden); Revd Basil Maltin; Bishop Askwith; Revd A. Maltin; the Bishop's chaplain; Mr D. Garnoch-Jones, (lay reader); and Mr R. Walker, (churchwarden). The 2009 photograph shows, again from left to right, Revd Ann Morris; Revd Canon Dr M. O. Tucker, retiring rector; and Mrs Anne Seymour, reader.

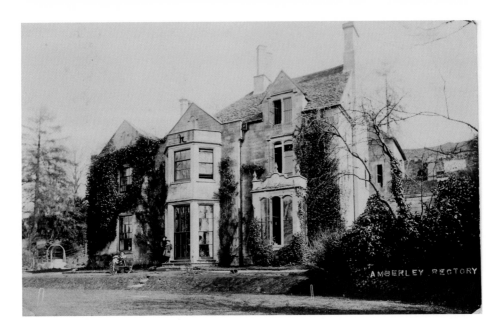

A Remarkable Family

Here we see Amberley's original rectory around 1908, when Revd Henry Summerhayes was the incumbent. This gentleman had a large family, mostly girls, several of whom may just be glimpsed in front of the building, which was later replaced by the present structure. What distinguished this remarkable family was that the girls all lived into their nineties – Mercy, the eldest, to over 100 – and were featured, twenty or so years ago, in a television programme called *Into the Nineties*. Mercy (left) Noel and Grace (right) visited the scene of their childhood for the 1992 Amberley School summer fête, when a BBC cameraman filmed them. The author visited Noel at her home where, at the age of ninety-seven, she still enjoyed playing in a string group.

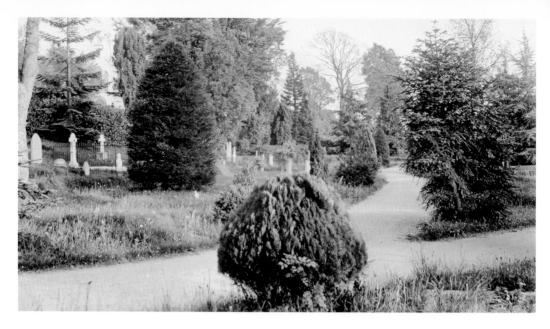

The Amberley Graveyard

Since Amberley lies in an area possessing many fine houses, it is hardly surprising that the graveyard contains some interesting monuments. Included are those of P. C. Wren, the author of *Beau Geste*, and Major-General Sir Fabian Ware, 1869-1949, who was created Permanent Vice Chairman of the War Graves Commission in 1919 and was responsible for inaugurating the system for marking the final resting place of all our war dead. Paul Smith's picture from the 1890s may be compared accurately with a current view because it is possible to stand almost exactly where he did. The clues are the pointed gravestone on the left (now leaning) and several others close by. What was a broad avenue in the nineteenth century is now the cremation memorial plot.

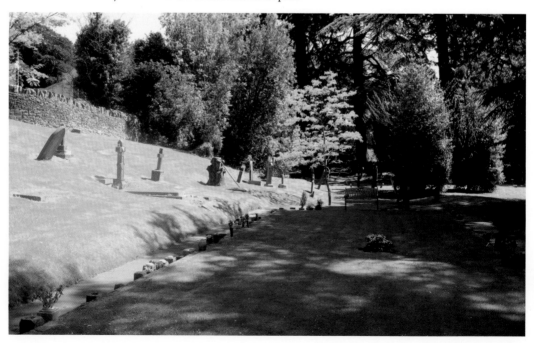

Littleworth Methodist Chapel

Littleworth Chapel was founded in 1797 and has registers commencing in 1814. A small graveyard is attached to the rear of the building. The upper picture dates from around 1907. The lower one, reproduced to show the interior, was taken on the occasion of the marriage of Trevor Payne to Marion Davis on 28 March 1959. The minister conducting the ceremony is Revd R. Rivett and the groom's cousin, Wilfred Payne, is the organist. Mrs Payne still lives in Amberley. The chapel, now in private hands, is currently an artist's studio.

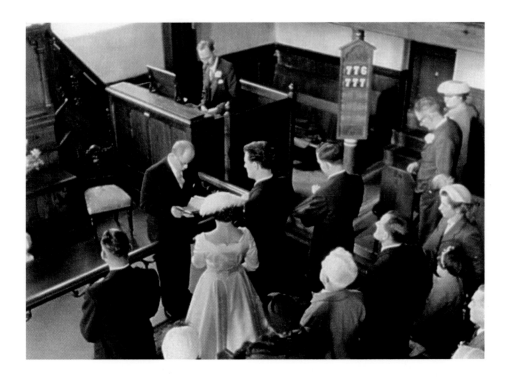

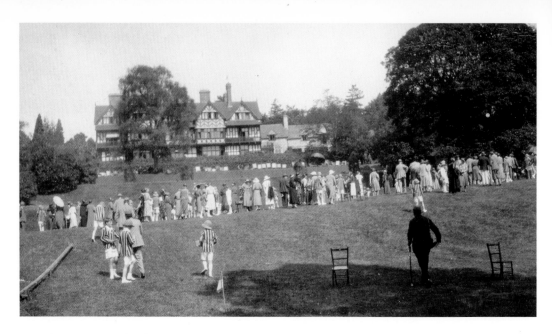

Beaudesert Park School

Built in Tudor half-timbered style by J. G. Frith in the 1860s, on the site of an earlier structure, Beaudesert Park was initially called The Highlands. It remained a private house until 1918 when a Prep School from Beaudesert, near Henley-in-Arden in Warwickshire, occupied it, bringing with it the name. Originally founded in 1908 as a boys' boarding school, by 1987, when the author's wife was appointed head of the Pre-Prep Department, it was a co-educational day and boarding establishment. The earlier picture is a homemade postcard showing a sports day in the 1920s. Amusingly, it has been printed back to front. The modern picture is of a later sports day *c.* 1990.

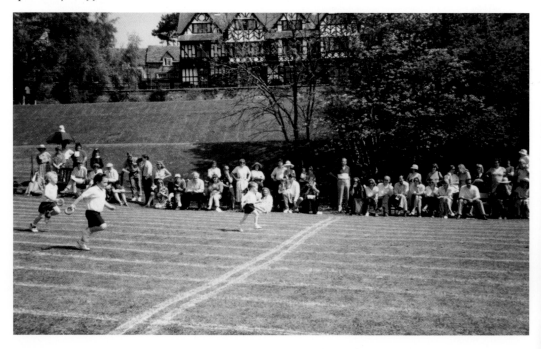

The Courtyard, Beaudesert Park

When The Highlands was a private house the wing seen here was the servants' hall and ancillary rooms. When it became a school the ground floor was subdivided into three classrooms, with a dormitory above. As the present day picture shows, the Pre-Prep Department was built onto the right-hand end of this wing. The two classrooms visible in the modern picture were opened in January 1987. The author himself joined the school in September of the same year, teaching in a classroom to the right of the green door. A hall, staffroom and four further classrooms were added in 1995. He retired from the school in 2003 and spends his time travelling, making music, also writing and lecturing on local history.

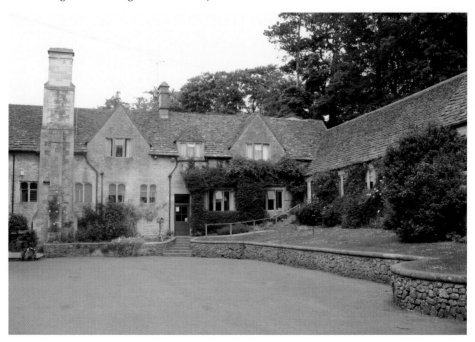

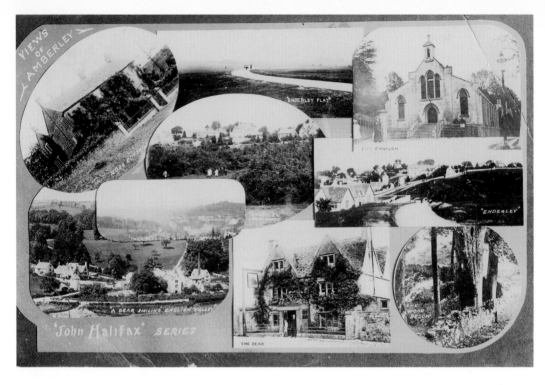

A postcard, sent in 1911, consisting of places in Amberley mentioned in Mrs Craik's *John Halifax, Gentleman*

Acknowledgements

I am indebted to Maureen Anderson, Peter Griffin, Ann Seymour and Diana Wall for proof reading the text.

I also wish to thank the following:
Amberley Archives, The Amberley Inn, Amberley Ridge Special School, Mrs J. Corry, P. Farley, Mrs M. Gardner MBE., P. Godfrey and the children of Amberley Parochial C.E. School, P. Hankins, R. Harris and the children of Minchinhampton Parochial C.E. Primary School, Miss A. Jones, K. Jones, J. Kirkwood, the late J. Lines, M. Mills, Minchinhampton Local History Group, Mrs S. Morris, Mrs S. Morris, Mrs M. Payne, T. Picken, A. Price, M. and S. Robinson, R. Sharpe, C. Shellard, A. Simmonds, Mrs H. Sparkhall, Stroud Court Community Trust, Mrs J. Thomas, A. Vaughan, J. Womersley.

Finally I would like to thank my wife, Sylvia, for all her continued assistance.